LÁSZLÓ MOHOLY-NAGY

J0668809

PHOTOGRAPHS

from

THE J. PAUL GETTY MUSEUM

The J. Paul Getty Museum

Malibu, California

In Focus
Photographs from the J. Paul Getty Museum
Weston Naef, *General Editor*

© 1995 The J. Paul Getty Museum
17985 Pacific Coast Highway
Malibu, California 90265-5799

Christopher Hudson, *Publisher*
Mark Greenberg, *Managing Editor*

Library of Congress
Cataloging-in-Publication Data

Moholy-Nagy, László, 1895–1946.
 In focus. László Moholy-Nagy : photographs
from the J. Paul Getty Museum.
 p. cm.
 ISBN 0-89236-324-X
 1. Photography, Artistic. 2. Moholy-Nagy, László,
1895–1946. 3. J. Paul Getty Museum—Photograph
collections. 4. Photograph collections—California—
Malibu. I. J. Paul Getty Museum. II. Title. III. Title:
László Moholy-Nagy.
TR653.M629 1995
779'.092—dc20 94-42443
 CIP

Contents

John Walsh **Foreword** **4**

Katherine Ware **Introduction** **5**

Plates **9**

Thomas Barrow **The Vision of** **87**
Jeannine Fiedler **László Moholy-Nagy**
Charles Hagen
Hattula Moholy-Nagy
Weston Naef
Leland Rice
Katherine Ware

Chronology **123**

Foreword

The first book in this series was devoted to Moholy-Nagy's countryman André Kertész. The two followed parallel career paths but never met. And despite many similarities in their experience of life, despite their shared belief in the power of art, they could not have been more different as photographers. Kertész pictured daily experience in surprising, revealing ways, while Moholy-Nagy took familiar things and transformed their appearances radically, even abandoning the camera to do so.

We hope that this little book brings discoveries to its readers, both through the reproductions of Moholy-Nagy's remarkable images and through the lively discussion of his work that follows. I am grateful to Katherine Ware for taking charge of this project; to Charles Hagen for guiding the colloquium and editing the result; and, once more, to the impresario and general editor of this series, Weston Naef.

John Walsh, *Director*

Introduction

I do not believe so much in art as in mankind.

Every man reveals himself; much of it is art.

—László Moholy-Nagy, *The Little Review,* May 1929

The period between the world wars was a socially and politically turbulent one that gave rise to many utopian dreams. In Germany, the need to formulate entirely new civic institutions to replace the shattered monarchy was particularly acute. Many artists felt that they had a crucial role to play in shaping society, and the search for a new order became a profound spiritual quest, with the responsibility of ensuring the future well-being of mankind. Traditional representation and materials were part of the old order; revolution called for a new approach. Therefore, many artists declared the death of painting and experimented with industrial materials and techniques such as photomontage in order to portray modern life in a new manner.

László Moholy-Nagy believed that the art of the past was not relevant to contemporary times and sought new ways to convey the vitality, complexity, and immediacy of twentieth-century urban culture. He also believed that the relationship between man and machine could be a fruitful one and that technology could be used to foster creativity. The camera was thus an ideal vehicle for him—a machine for seeing with the potential for inventing a fresh vocabulary of light and form. He explored and extolled its possibilities in his art and writing throughout his life. Moholy-Nagy, known as Moholy to friends and colleagues, never considered himself a photographer, although he produced a large and varied body of work in that medium. A tireless creator, he also found expression in painting, sculpture, film, graphic and stage design, writing, and teaching.

In forging his own artistic style and philosophy, Moholy-Nagy looked primarily to the Russian Constructivists and to the Suprematist paintings of Kasimir Malevich. He was also inspired by the De Stijl movement led by Theo van Doesburg and Piet Mondrian, the Dadaists in Berlin, and the Italian Futurists. His work with Walter Gropius at the Bauhaus, where he taught from 1923 to 1928, had a profound effect on his development. Moholy-Nagy was a remarkably inventive artist, and many of the issues he raised but did not fully pursue have provided fertile ground for later artists. He had a voracious appetite for visual information and a startling talent for absorbing disparate influences, although these elements were not always cohesively integrated in his work. He was sometimes accused of plagiarism, of promoting theories and approaches that he did not originate, but it seems clear that he was less concerned with authorship than with communication and dissemination. By all accounts his greatest pleasure was in broadcasting the ideas that excited him, making him an inspiring teacher at the Bauhaus in Weimar and Dessau and the New Bauhaus and the School of Design (later the Institute of Design) in Chicago. The sense of community at these institutions was clearly vital to his creativity.

Moholy-Nagy's photographic work can be divided into three areas: cameraless photographs, or photograms; photographs made with a camera; and photomontages (which he called *fotoplastiks*), in which existing photographs or reproductions are combined and rephotographed to create new meaning. An indefatigable experimenter, he seems to have worked in these areas simultaneously while continuing to pursue projects in painting, sculpture, film, and commercial design.

The images reproduced in this book are drawn from the collection of the J. Paul Getty Museum, which includes eighty-two photographs and nineteen other works in various media by Moholy-Nagy. These were acquired over the past ten years from a number of sources, primarily the Arnold Crane Collection. The works presented here date to Moholy's years in Germany (1920–34) and range from a circa 1923 photogram to a 1930 photograph from Norway. This time frame, which includes Moholy's stint at the Bauhaus, was perhaps his most fertile photographic period. The illustrations were selected to showcase the strengths of the Getty holdings of photographic work by Moholy-Nagy and to expose readers to a diverse sampling of the artist's work in this medium.

Almost without exception, works by Moholy-Nagy in this collection are

Lucia Moholy. *László Moholy-Nagy,* circa 1927.
Gelatin silver print with gouache, 8.3 × 5.8 cm.
85.XP.384.43.

signed on the verso of the print or carry a wet stamp that establishes his authorship. In many cases the title and date are given by the artist, and additional notations by Lucia Moholy and Sibyl Moholy-Nagy can be identified. Prints are understood to have been created around the time the negative was made, unless otherwise noted.

Many of the photomontages presented here exist in variant prints in the Getty collection. Moholy-Nagy was not a proponent of the photograph as a precious, one-of-a-kind art object. Nevertheless, he did not produce numerous prints. In many cases he made photographs as a necessary step in the process of realizing an image on the printed page. Duplicate prints were sometimes made in order to explore an alternate version of an image or for publication in European avant-garde journals and other publications. Moholy-Nagy believed in photomechanical reproduction as an aid to art education, an example of technology serving human spiritual needs.

In very few cases the original montages from which the *fotoplastiks* were made are preserved; one of these is in the Getty collection, and a few remain in other

institutions. However, it seems clear that for Moholy-Nagy the content of the image was most important, and these montages did not constitute a higher artistic form than the photographs he made of them. The whereabouts of most of Moholy-Nagy's negatives is unknown; they are presumed to have been lost.

Following the plate section is an edited transcript of the colloquium devoted to Moholy-Nagy's photographs that was held at the J. Paul Getty Museum in 1994. Each of the participants has a particular interest in the artist's work. Thomas Barrow is a photographer and professor at the University of New Mexico in Albuquerque whose work has an affinity with Moholy-Nagy's photographs and who has written about the photogram. Jeannine Fiedler is an independent scholar formerly with the Bauhaus-Archiv in Berlin; she has written numerous pieces on photography, the Bauhaus, and Moholy-Nagy. Hattula Moholy-Nagy, an archaeologist who lives in Ann Arbor, Michigan, is the artist's daughter and executor of the László Moholy-Nagy estate. Weston Naef, Curator of Photographs at the J. Paul Getty Museum, acquired the group of Moholy-Nagy photographs for the Museum and has had a long-standing interest in the artist's work. Leland Rice is a photographer and curator who has extensively studied the photographic work of Moholy-Nagy; he and David Steadman prepared the 1975 exhibition and catalogue *Photographs of Moholy-Nagy,* presented at the Galleries of the Claremont Colleges in Claremont, California. My own interest in Moholy-Nagy stems from an enduring fascination with the rich variety of art produced in Europe in the turbulent 1920s and 1930s.

The participants were encouraged to share their ideas and opinions about a group of Moholy-Nagy photographs from the collection, with the hope of gaining new insight into the complex work of this artist. The colloquium moderator was Charles Hagen, an art critic for the *New York Times.* Special thanks go to the colloquium participants and to the staff of the Getty Museum who assisted with this project, particularly Suzanne Baumann, Maura Christensen, Julian Cox, Stepheny Dirden, Quinten Garth, Michael Hargraves, Marc Harnly, John Harris, Cathy Klose, Charles Passela, and Leslie Rollins. The contributions of the following individuals who shared information about Moholy-Nagy and his art are also gratefully acknowledged: Lloyd Engelbrecht, Eleanor Hight, Nathan Lerner, Floris Neusüss, and Robert Shapazian.

Katherine Ware, *Assistant Curator, Department of Photographs*

Plates

PLATE I

Photogram

Circa 1923

Gelatin silver print
12.2 × 17.6 cm
84.XM.997.62

Moholy-Nagy considered himself foremost a painter but became intensely interested in the creative possibilities of photography in the early 1920s, after emigrating from his native Hungary to Germany. He began his experiments with the medium around 1922 in collaboration with Lucia Moholy (the former Lucia Schulz), whom he had met in 1920 and married in 1921. This photogram appeared in his important 1925 publication *Malerei, Photographie, Film* (Painting, photography, film) and bears a close affinity to his paintings of this period, in which he strove to eliminate shapes reminiscent of nature and sought to explore the relationships of light, color, and nonobjective form. With photograms, Moholy could actually make a picture with light, by bringing objects or shadows in contact with light-sensitive photographic paper, which he exposed to a light source. "The organization of light and shadow effects produce a new enrichment of vision," he wrote in the caption to this piece. The objects used to make the shapes produce a dematerialized and otherworldly effect.

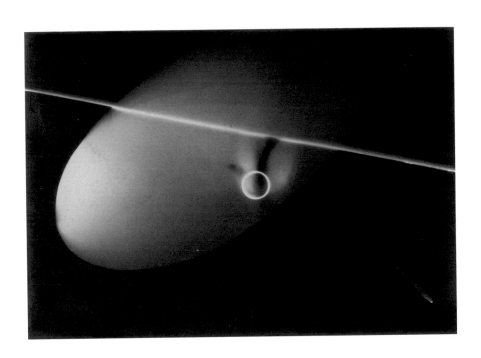

PLATE 2

Photogram

Circa 1924

Gelatin silver print
23.9 × 29.9 cm
84.XM.231.4

In the early 1920s Moholy's Berlin studio was a popular gathering place for artists, including the Russian painter El Lissitzky and the Dadaists. In 1922 Moholy-Nagy attended the Dada-Constructivist Congress in Weimar. It seems likely that he would have heard of the work of Christian Schad, a Zurich Dadaist who in 1918 had made a series of small pictures directly on photosensitive paper (Schadographs), and that of Man Ray in Paris, whose suite of photograms (Rayographs) *Les champs délicieux* (The fields of delight) was published in 1922. Moholy-Nagy was not interested in making identifiable pictures of objects in his photograms; he sought instead to achieve abstract effects with everyday items. On the back of this dynamic image, which once belonged to the Russian poet Vladimir Mayakovsky, Moholy-Nagy identifies the compositional elements as two napkin rings and some wooden matches but also writes: "But is that important in the end? How the light flows in tracks and what becomes of the whole has nothing to do anymore with the original material."

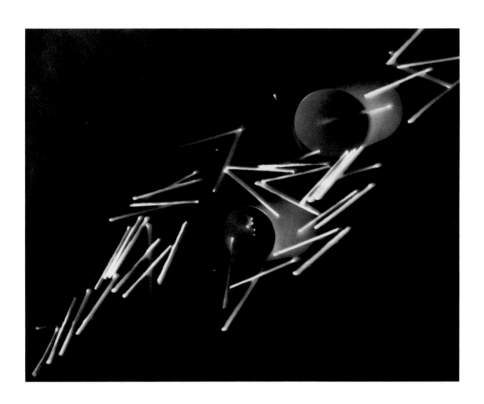

PLATE 3

The Farewell

1924

Gelatin silver print
of a photomontage
39.0 × 29.0 cm
84.XM.997.9

Moholy-Nagy's use of photomontage was undoubtedly stimulated by his association with the Berlin Dadaists, particularly Raoul Hausmann. The Dadaists declared themselves "anti-art," and instead of drawing or painting a picture would assemble an image from preexisting elements, such as photographs or reproductions from popular magazines. The montage technique was a revolutionary way to represent and comprehend the urban culture of the twentieth century. Such *fotoplastiks*, as Moholy called his photographs of montages, "are grounded in that kind of cerebral and ocular gymnastics which most city dwellers are compelled to perform day by day," he wrote in the 1928 article "Fotografie ist Lichtgestaltung" (Photography is creation with light).

In this humorous artwork Moholy-Nagy used pictures from a variety of sources and augmented the composition with painting before photographing the whole construction. An industrial landscape is the backdrop for this melodramatic farewell scene of the sort seen in popular postcards and movies of the 1920s. The characters are more involved in their own exaggerated posing than in leave-taking, despite the train thundering below them; the two dogs seem to echo their respective moods. The pastiche quality of this piece suggests that it may have been made at the beginning of Moholy's work with photomontage, which he would employ extensively throughout his career.

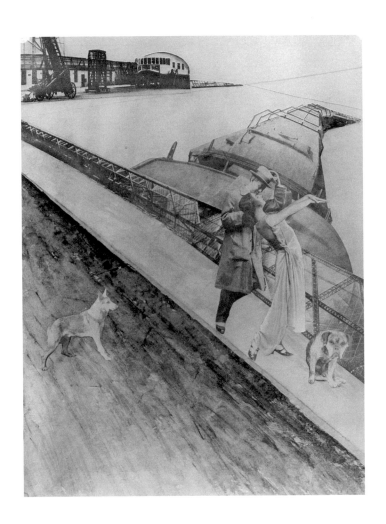

PLATE 4

The Benevolent Gentleman

1924

Gelatin silver print
of a photomontage
29.4 × 21.8 cm
84.XM.997.33

In the spring of 1923 Moholy-Nagy was invited to join the faculty of the Bauhaus in Weimar, an innovative state-supported school of art, architecture, and design under the direction of Walter Gropius. In this stimulating environment he produced many photographic works. This piece first appeared in the 1925 book *Die Bühne im Bauhaus* (The theater of the Bauhaus), written by Moholy-Nagy, Oskar Schlemmer, and Farkas Molnár. Indeed, the graduated platform at the bottom of the composition suggests a stage. In his essay in the book, "Theater, Zirkus, Varieté" (Theater, circus, variety), Moholy-Nagy envisions drama as a primarily visual experience, perhaps accompanied by tones or music, but liberated from text. The actor, instead of being the focus of a production, is of equal importance with other dramatic elements—light, space, sound, and motion—and can be replaced by puppets or mechanical figures. Thus circus performances and variety shows came closest to his conception of the ideal theater.

In its juxtaposition of figures, this work reflects Moholy's ideas about the simultaneity of new theater and a closer interaction between audience and performer, although in a purely exaggerated, suggestive manner. From a visual standpoint, the abstract backdrop is in a style related to his Constructivist paintings of this period; the dynamic lines prefigure the drawing he would use to activate many of his montages.

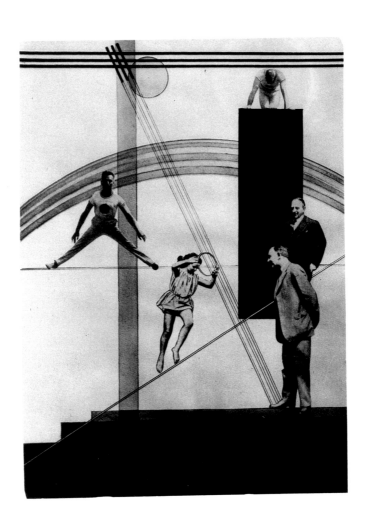

PLATE 5

PLATE 6

Stage Scene
Loudspeaker
1924

Stage Scene
Loudspeaker
1924

Gelatin silver print
of a photomontage
29.4 × 22.2 cm
84.XM.997.41

Gelatin silver print
of a photomontage
16.9 × 12.4 cm
84.XM.997.5

Moholy-Nagy was enthusiastic about the creative potential of the phonograph and predicted that it would supersede all other musical instruments. He wrote several articles on the subject and used the loudspeaker image to illustrate his essay in *The Theater of the Bauhaus.* As early as 1922 he suggested that a composer could create his work directly on a disc, incising it with graphic patterns, without having to rely on traditional musical notations or the skill of performers. Instead of simply reproducing familiar sounds, the phonograph would create sound. Similarly, Moholy felt that the camera should be liberated from its role of recording the natural world in order to create abstract pictures of light and form. The suspended mechanical elements pictured here are not intended for practical application but are Moholy's shorthand for communicating energy and his excitement about the possibilities of the phonograph.

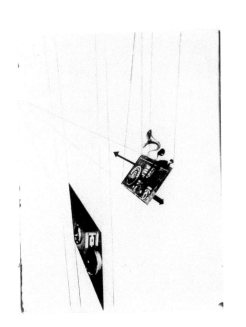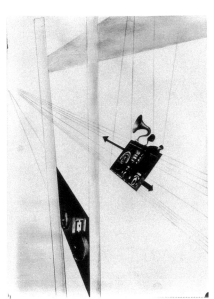

PLATE 7

PLATE 8

Boxing

1924

Gelatin silver print
of a photomontage
17.8 × 12.8 cm
84.XM.997.50

Adam Sporting Goods

1924

Gelatin silver print
of a photomontage,
with graphite, ink, gouache
14.9 × 11.2 cm
84.XM.997.1

In *Boxing,* Moholy-Nagy has created a
stage set/architectural space for his charac-
ters: a boxing ring (drawn by hand). The
enclosure—a box as well as a boxing ring—
parallels that of the caged cheetah above.
The pugilist is tamed by his zoological
confinement and appears as a somewhat
ridiculous figure, his antics under amused
observation by a group of women in
1920s bathing suits and men in military
uniforms with surveying equipment.
The artist later reworked this piece for use
as an advertising design by adding the
word *Sportartikel* (sporting goods), paint-
ing the name *Adam* in red, and applying
gouache to the figures. According to
Lucia Moholy, the design was never used
commercially.

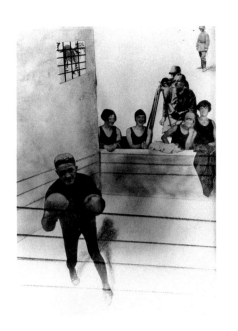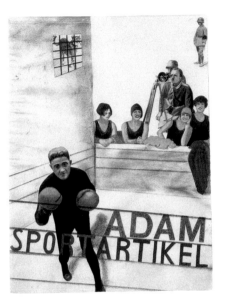

PLATE 9

Militarism/Propaganda
Poster

1924

Gelatin silver print
of a photomontage
17.9 × 12.8 cm
84.XM.997.17

The period after World War I in Germany
was one of social and political upheaval. In
January 1923 a vote by the Allied Repara-
tions Commission determined that Ger-
many had not fulfilled the conditions of the
Treaty of Versailles, and French troops
occupied the Ruhr region. Miners and rail-
road workers went on strike, causing an
economic crash. A state of emergency
was declared by President Friedrich Ebert
in September, but a loss of confidence in
the government resulted in a chaotic situ-
ation in which extremist political groups
sought to gain control of the country. The
violent vision of Moholy's *Militarism* may
reflect this milieu, showing unevenly armed
forces facing off against each other. At the
end of 1923 stringent financial reforms
were instituted to halt inflation. By 1924 the
economy had stabilized.

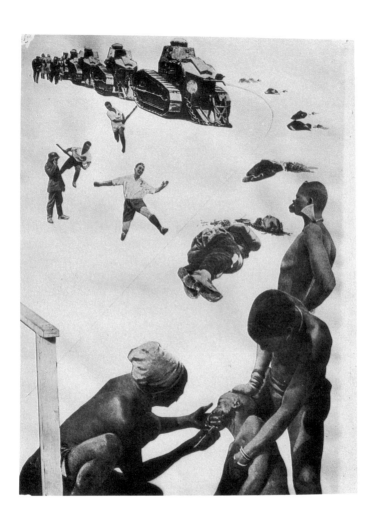

PLATE 10

Our Big Men

1924

Gelatin silver print
of a photomontage
14.1 × 19.6 cm
84.XM.997.19

After the death of Friedrich Ebert in 1925,
Field Marshal Paul von Hindenburg was
elected president of Germany. German
art historian Irene-Charlotte Lusk identi-
fies Hindenburg and Foreign Minister
Gustav Stresemann as the politicians pic-
tured in *Our Big Men,* accompanied by
their larger-than-life shadows and Hin-
denburg's oversized top hat and cigar. The
anonymous common man between them
may be dwarfed and cornered by these two
august officials, but their hats are off to
him and he stands at the apex of the trian-
gle formed by the three figures. The title
pokes fun at the two leaders, suggesting
ineffectualness. Stresemann, however, who
shared the 1926 Nobel Peace Prize with
Aristide Briand of France, was essential in
restoring prosperity to Germany.

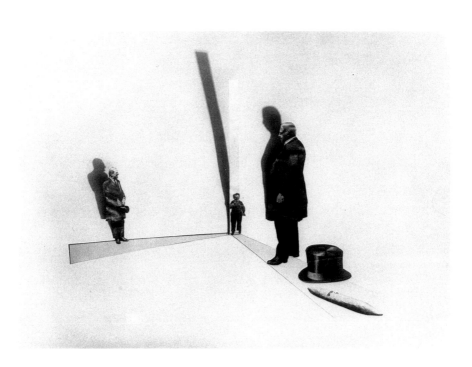

PLATE 11

Gutter

1925

Gelatin silver print, toned
37.0 × 27.4 cm
94.XM.28

Here Moholy-Nagy has used a camera to
transform muddy water into a masterpiece
of light and texture. Photographed during
a summer visit to Paris, the quotidian
subject matter of a street drain offers the
raw materials for this abstract composition.
The strip of fabric diverting water into
the drain becomes a slashing diagonal line,
while the drain itself is transformed into
a perforated rectangle, echoing the shapes
used by the artist in his paintings and
bearing a close affinity to the effects he was
trying to achieve in his photograms.

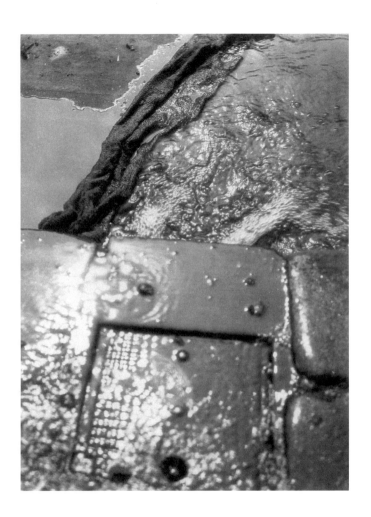

PLATE 12

The Broken Marriage

1925

Gelatin silver print
of a photomontage
17.8 × 12.6 cm
84.XM.997.6

The husband and wife in this image are
two-faced in both senses—their faces
are fused onto the same head and neither
seems to wear an honest expression.
Although the woman smiles brightly, she
supports her chin like Rodin's *Thinker,*
sightlessly pondering her situation. Mean-
while, her husband's eyeglasses stray
toward a projection of another woman,
to whom he extends his hand. A mass of
electric curlers protrudes in all directions
from the couple's head, suggesting his
current of attraction to the woman on the
screen and his wife's strategy of a new
hairdo as an antidote to infidelity. Another
woman's hand emerges from the wall,
delicately reaching toward a pair of star-
ing eyes. Perhaps due to the domestic
subject, Moholy-Nagy has created an elabo-
rate architectural space for the unhappy
couple, a constricting room with windows
and many overlapping side panels.

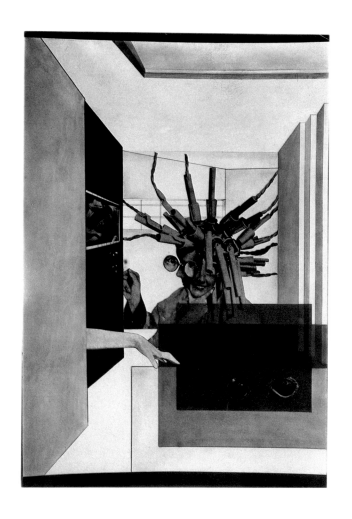

PLATE 13

Dream of the
Boarding School Girls

1925

Gelatin silver print
of a photomontage
16.8 × 12.0 cm
84.XM.997.28

In this work Moholy-Nagy presents us with
three different performances: uniformed
boarding school girls dutifully lined up in
an H configuration, leaping male athletes,
and two female contortionists. Presumably
the boarding school girls yearn to break
free of their formation in order to achieve
the independence and individuality of the
figures sporting before them. The artist's
characteristic Constructivist lines connect
the elements of the composition and lend it
dynamism. They also suggest the precision
of architectural or engineering plans.

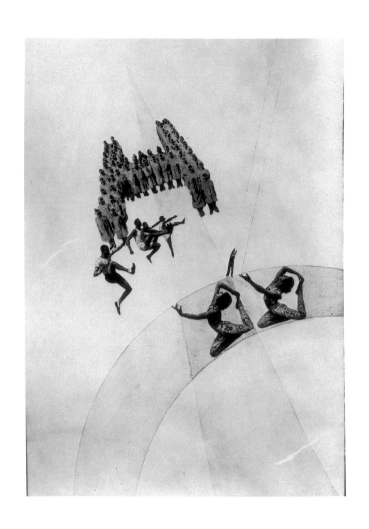

PLATE 14

**The Structure
of the World**
1925

Gelatin silver print
of a photomontage
24.4 × 17.9 cm
84.XM.231.2

No longer tied to a traditional construction
of pictorial space as in *The Farewell* of
1924 (pl. 3), this work takes greater liber-
ties with space and form and exemplifies
Moholy-Nagy's own style of montage.
The artist wished to bring order to the
layering of elements in his montages and
maximize their legibility for the viewer,
unlike the chaotic and image-packed
work of the Dadaists. Despite this order-
ing, the meaning of the piece is meant to
be associative rather than assigned.
The deep significance suggested by such
a ponderous title is not readily discern-
ible. According to Lucia Moholy, a title
was generally added after a composition
was completed rather than being part
of its genesis. In this whimsical piece the
universe is shown to be composed of a
scaffolding of Constructivist beams and
women's legs, which provides shelter
for a monkey treed by aggressive pelicans.

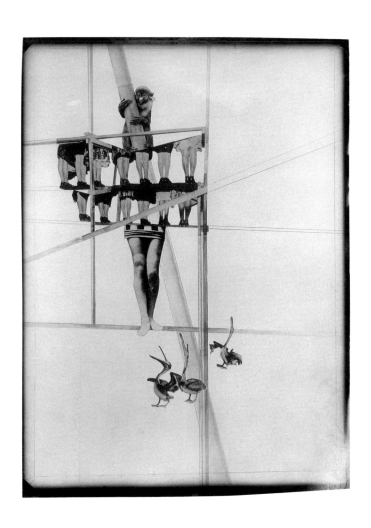

PLATE 15

**Between Heaven
and Earth**

1925

Gelatin silver print
of a photomontage
23.7 × 18.8 cm
84.XM.997.23

Like *The Structure of the World* (pl. 14),
Between Heaven and Earth (also known
as *Behind the Back of God*) is charac-
teristic of Moholy's mature montage style.
The events pictured here unfold in a kind
of filmic, stop-action sequence emanating
from a circle that could represent the
mouth of a cannon. From out of this aper-
ture emerges a figure with flailing arms
who is melded with a person using a blow-
gun. A child tumbles midway; another
form lands in the sunflower-like fireman's
net below. The three lines create a sense
of velocity and suggest marionettes being
manipulated by a higher power.

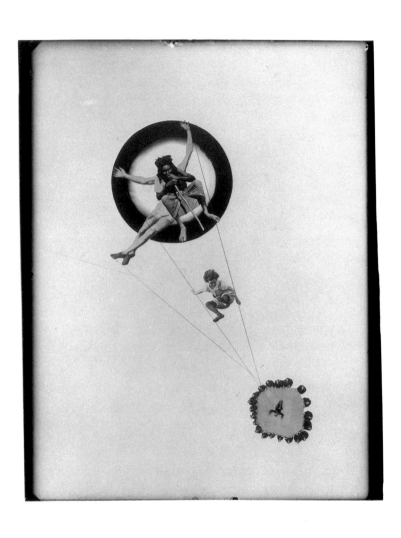

PLATE 16

Love Your Neighbor/
Murder on the
Railway Line
1925

Gelatin silver print
of a photomontage
38.8 × 27.2 cm
84.XM.997.10

The overlapping circles in this composi-
tion, which connote the range finder of
a rifle, also suggest a fast-breaking simul-
taneity of events, with a female sharp-
shooter and scenes from a railway station
and a colonnade. Standing outside the
circles, a female gymnast engaged in
weightlifting is seemingly unaware of the
gun trained at her chest. A network of
precise pencil lines crosses and recrosses
the page, creating a complicated web
of connection. Unlike the traditional static
picture, this superimposition of form was
meant to "act upon the viewer in an
exhilarating, touching, appalling, satirical,
visionary, revolutionary way," as Moholy
wrote in his 1928 essay "Photography Is
Creation with Light." No specific narrative
is intended, but the artist was attempting
to excite sensations in his audience,
which would comprehend the work on an
intuitive rather than cerebral level.

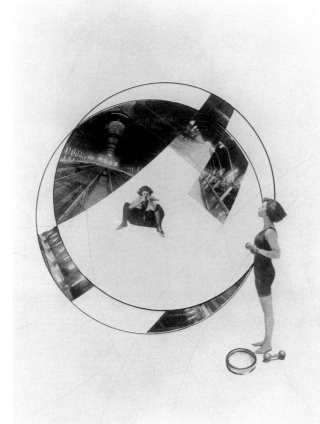

PLATE 17

The Law of the Series

1925

Gelatin silver print
of a photomontage
22.2 × 17.1 cm
84.XM.997.4

PLATE 18

**The Transformation/
Anxiety Dream**

1925

Gelatin silver print
of a photomontage
25.0 × 18.5 cm
84.XM.997.43

PLATE 19

**Advertisement for
Schocken Department
Store**

1927

Gelatin silver print of a
photomontage, with ink
21.6 × 16.3 cm
84.XM.997.2

Photography's capacity for reproduction made it possible to produce several variants of a piece, as seen in this series, begun in 1925. It features variations on a portrait of Marcel Breuer, a student at the Bauhaus who was subsequently appointed head of the furniture workshop in April 1925. Like Moholy-Nagy, Breuer was born in Hungary and was a close ally of Gropius; he later became a celebrated architect.

In *The Law of the Series* Moholy seems to be experimenting with the dynamic potential of the repeated image, flopping the negative back and forth to produce five versions of Breuer augmented by a focal circle and receding curved lines. In the variant print *The Transformation*, Breuer's figure is again repeated, but altered by the addition of a ball and upside-down eyes from other faces (one pair belonging to the silent film star Mae Murray). Pencil lines around the figures indicate cropping for another print (also in the Getty collection), in which the three Breuers are enlarged and the white space around them is eliminated. The disturbing eyes in this version perhaps gave rise to the ambiguous alternate title *Anxiety Dream*. Ultimately, Moholy-Nagy adapted the series to advertise the Schocken Department Store in Nuremberg. The lines of force and the arrow unerringly convey the viewer to the store pictured in the upper-right-hand corner of the composition. Breuer becomes an economic traffic cop as he commands: "Stop! Have you been to the Schocken Department Store yet?"

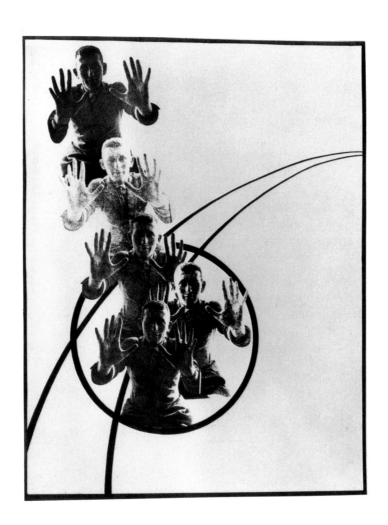

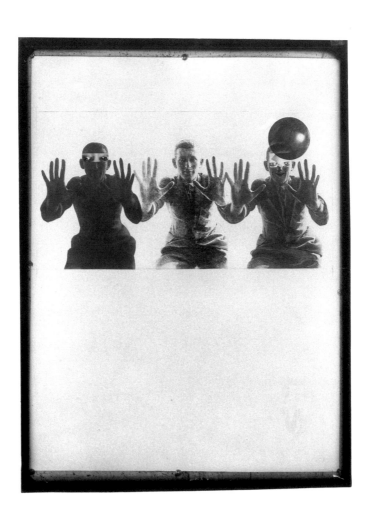

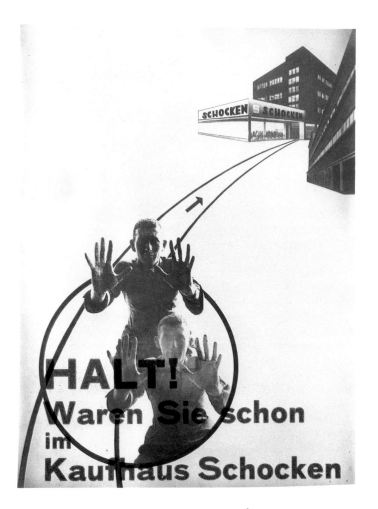

PLATE 20

The Water Head

1925

Gelatin silver print
of a photomontage
12.9 × 17.9 cm
84.XM.997.16

This image may be an oblique attack on Albert Renger-Patzsch, a contemporary of Moholy-Nagy who was the leader of the New Objectivity movement in German photography. Renger-Patzsch's *Factory Smokestack* was reproduced by Moholy-Nagy in his 1925 book *Painting, Photography, Film.* In the context of this montage, however, Moholy-Nagy seems to use the receding form of the smokestack and the constricted view through the diver's helmet to suggest tunnel vision on the part of Renger-Patzsch, who spoke out against the Bauhaus approach. The title, with its slang reference to stupidity and hydrocephalus (an abnormal accumulation of fluid in the cranial cavity that results in the expansion of the skull and atrophy of the brain) reinforces the negative visual message. The other diver, a cartoonlike buffoon, continues this idea.

Like Moholy-Nagy, Renger-Patzsch was deeply involved in issues of vision and perception and interested in using the medium of photography to record form and detail in order to give a fresh view of the familiar. Feeling that nature needed little improvement, however, he made photographs that celebrated the inherent beauty of trees as well as railroads and smokestacks, whereas Moholy advocated freeing the camera from reproducing nature. Renger-Patzsch's work was rejected by many of his colleagues for not being revolutionary enough, but he countered that much of contemporary photography consisted of "looking up/looking down," a reference to the exaggerated perspective favored at the Bauhaus and by Moholy-Nagy. Both extremes of vision seem to be represented here, from looking up at the smokestack to looking down into the deep. The open white space in this composition is a bold departure from Moholy's earlier montages, in which he created stage sets for his images. Here the three pictorial elements are connected only by thin pencil lines.

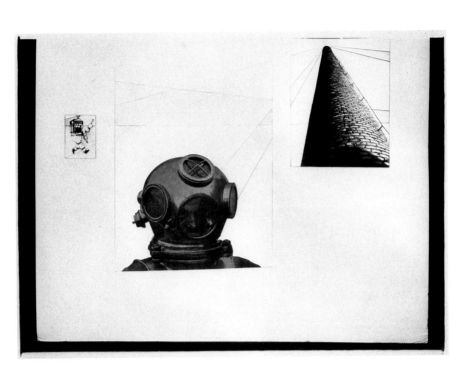

PLATE 21

Once a Chicken, Always a Chicken

1925

Gelatin silver print
of a photomontage, with ink
11.0 × 16.3 cm
84.XM.997.8

PLATE 22

Worship of the World Champion

1925

Gelatin silver print
of a photomontage
17.0 × 12.5 cm
84.XM.231.6

The montage *Once a Chicken, Always a Chicken* seems to be a comment on the changing role of women in Germany's postwar society. Pictorially, Moholy-Nagy makes the association between women and fertility and women as "chicks" with images of eggs and chickens. The title of the piece suggests that a chick cannot aspire to be anything more, perhaps a reference to growing negative reaction to the increasing visibility of working women and to their voting privileges. The strings connecting the female athlete with the X-rayed chicken seem to inextricably bind them. However, two athletes in the background have no such constraints; one raises her club as if to free the chicks from their eggs, the other springs forward as if just hatched. Inscribed by the artist at the bottom of this print are the words "Metamorphosis or the Easter Egg," contradicting the immutability of the sentence suggested by the original title.

"Once a Chicken, Always a Chicken" is also the title of a surrealistic "optical film manuscript" written by Moholy-Nagy between 1925 and 1930 in which many dreamlike transformations take place. The chicken appears again in *Worship of the World Champion*, where sky divers kneel in homage to the X-rayed hen in the spotlight, the circles at its extremities now representing boxing gloves. "The Annuciation Number 1" is inscribed on the back of this print, a humorous reference to the worship of the Christ child.

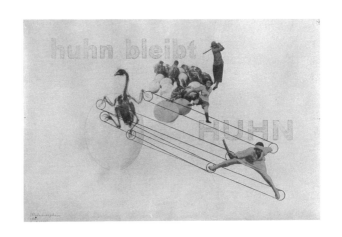

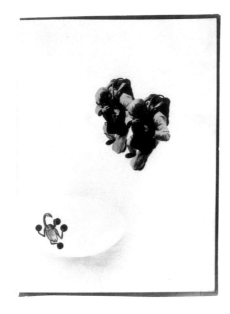

PLATE 23

Olly and Dolly Sisters

Circa 1925

Gelatin silver print
of a photomontage
37.4 × 27.5 cm
84.XM.997.24

According to the German art historian Irene-Charlotte Lusk, the title of this montage refers to the Dolly Sisters, a dancing team popular in Europe and the United States from 1911 to 1927. The identical twins, Jenny and Rosie, appeared at the Moulin Rouge and in the Ziegfeld Follies and were known for both their beauty and their gambling prowess. In his autobiography, Charlie Chaplin mentions having dinner once in Los Angeles with the sisters, their husbands, and Diamond Jim Brady, their constant companion. The twins are interred at Forest Lawn in Glendale, California.

Moholy has invented his own duo by changing the name slightly. One of the sisters is represented by only a spot for her head, while the other is perched on a black sphere, her plumed skirt cascading around her. The starkness of this composition might lead one to think of it as unfinished, but the size of the print and its inclusion in the 1929 *Film und Foto* exhibition as well as in Franz Roh's book *L. Moholy-Nagy: 60 Fotos* (1930) establish this as a completed work. The image is startling in its modernity and anticipates work by contemporary artists of the 1980s and 1990s.

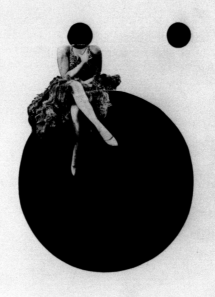

PLATE 24

Oskar Schlemmer

1926–27

Gelatin silver print
37.2 × 25.1 cm
84.XP.124.2

PLATE 25

Dolls

1926–27

Gelatin silver print
8.1 × 5.5 cm
84.XP.124.3

Oskar Schlemmer, a painter and leading figure in German experimental theater, was teaching at the Bauhaus when Moholy-Nagy arrived there in 1923. This portrait of Schlemmer is one of a series of four pictures taken on the same day on the balcony of the Casa Fantoni in Ascona, Switzerland, where Moholy-Nagy and Lucia Moholy joined Schlemmer's family for a vacation. Relaxing on a towel in the sun, Schlemmer becomes a design element in Moholy's camera study of light and form. The shadows of the railing produce a kind of photogram on Schlemmer's clothing, and the angle from which the picture was taken denies traditional perspective, flattening out the composition. In a variation on this image, Moholy has placed two dolls on a piece of paper in the same location as Schlemmer, imitating his position. Without Schlemmer's body filling the frame, the composition is even more successful in its palpable textural and tonal quality. It is also a more dramatic and menacing picture, with the dolls lying naked and helpless on their backs, trapped by the shadow grid of the railing, giving them a somewhat disturbing, Surrealist quality. Moholy-Nagy also photographed Schlemmer's two daughters—undoubtedly the owners of the dolls—in this pose and made another variation with just one doll.

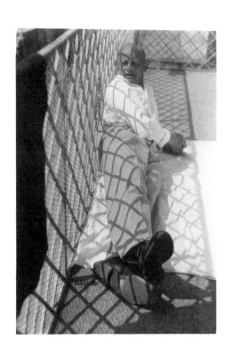

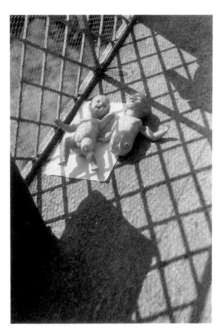

PLATE 26

Rothenburg

1926–28

Gelatin silver print
23.9 × 18.1 cm
84.XP.124.1

In 1925 the Bauhaus closed in Weimar due to political pressures and the withdrawal of state funding. The school's new facility in Dessau was designed by architect and Bauhaus director Walter Gropius. The medieval city of Rothenburg ob der Tauber, perhaps a vacation destination during Moholy-Nagy's residence in Dessau, would have provided a stark contrast with the glass and steel of the Bauhaus buildings. This very modern view of the ancient city employs Moholy's favored bird's-eye view, a device used in many of his camera images and photomontages to present familiar scenes in an unfamiliar, and therefore stimulating, manner.

Moholy was interested in discovering the camera's unique contributions to seeing, and his explorations were aided by the advent of lightweight, portable equipment.

The high vantage point of this rooftop enabled him to capture the photogramlike shadows cast by the setting sun. The stripe down the middle of the road, the dark circle of the fountain, and the shape of the building in shadow in the foreground are consistent with his concern with light and form in all media.

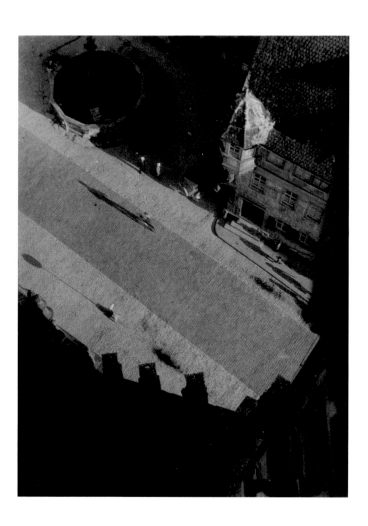

PLATE 27

Joseph and Potiphar's Family

Circa 1926

Gelatin silver print
of a photomontage
11.7 × 17.4 cm
84.XM.997.22

The title of this piece refers to the Old
Testament story of Joseph, who, after being
sold by his brothers into slavery, rose to the
rank of overseer in the house of Potiphar,
the captain of the pharaoh's guard (Genesis
39). After Joseph spurned the advances of
Potiphar's wife, she accused him of trying to
seduce her, causing him to be jailed.

The most arresting figure in this
composition, an emaciated young man sup-
porting his weight on a crutch, seems
unmoved by the advances of the languid
coquette across from him, who presses
her body against a translucent three-
dimensional form (a form that recurs fre-
quently in Moholy-Nagy's work). In the
background, another man turns his back on
the couple and averts his gaze from the
two pairs of bare legs before him. The lines
drawn on either side of him (tightropes,
suggests the American art historian
Julie Saul) indicate that there is no escape
from the situation.

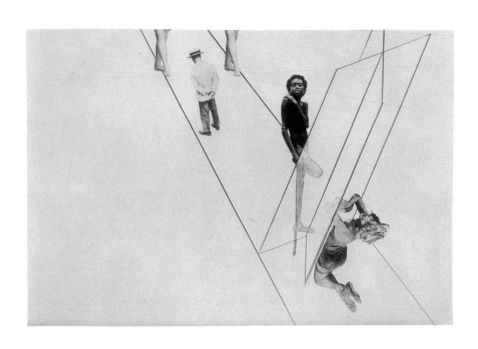

PLATE 28

Rape of the Sabine

1927

Gelatin silver print
of a photomontage
21.1 × 15.7 cm
84.XM.997.13

The dynamic tension between two groups
of figures—Moholy's interpretation of
the story of the rape of the Sabine women—
is the focus of this piece. While the statu-
esque flapper dances with her nearly
invisible partner, a group of strongmen
struggle to fell her in a tug-of-war. Women's
rights became an increasingly polarized
issue in postwar Germany, pitting the
"new woman" against the traditional wife
and mother. At a time of concern over re-
populating the decimated country, women's
increased sexual freedom was viewed with
anxiety. Rising unemployment—particu-
larly in industry—fueled a backlash against
female employees, and families in which
both the husband and wife worked outside
the home were subject to criticism.
Moholy's Sabine appears to be able to take
care of herself, however.

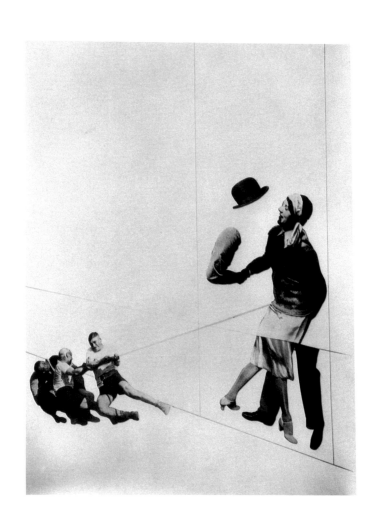

PLATE 29

Look Before You Leap/
Sport Makes Appetite

1927

Gelatin silver print
of a photomontage
13.4 × 18.8 cm
84.XM.997.48

Here Moholy-Nagy continues to experiment
with methods of animating the still pho-
tograph. The curving lines and shaded sec-
tion of the overlapping circles in this
composition provide a dynamism worthy
of the leaping athletes and recall a
schematic drawing for simultaneous film
projection in *Painting, Photography,
Film.* Two pairs of women's legs provide a
kind of hurdle or finish line; one of the
jumpers takes the picture's title to heart
and looks down before leaping past the
disembodied limbs. At left, a large woman
in heavy clothing remains stationary in
her own circle. An inscription in pencil at
the bottom of the print warns, "Exercise
or be fat," a possible advertising slogan or
simply words to live by at a time when
sports were of increasing popular interest.

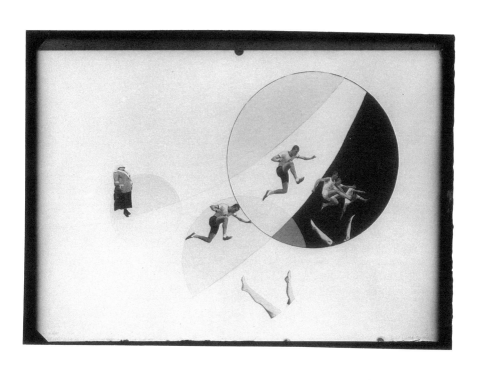

PLATE 30

My Name Is Rabbit,
I Know Nothing

1927

Gelatin silver print
of a photomontage
21.4 × 17.7 cm
84.XM.997.47

Although Moholy-Nagy's montages are
never as directly political as those of his
Dadaist compatriots, such as John
Heartfield or Hannah Höch, his work
is often infused with social criticism. In
this piece, an individual masked in
whiteface shrugs obliviously while three
figures struggle precariously overhead
on high wires. The dance historian
Frank-Manuel Peter has identified the
anguished figure at the far left as
Valeska Gert, performing her dance piece
Nervousness. The German expression
Mein Name ist Hase, ich weiss von nichts
(My name is rabbit, I know nothing)
indicates silent complicity, the keeping
of a confidence or secret. In this con-
text, Moholy's use of the phrase seems
to comment on those who witness
the problems around them but do not
speak out against them.

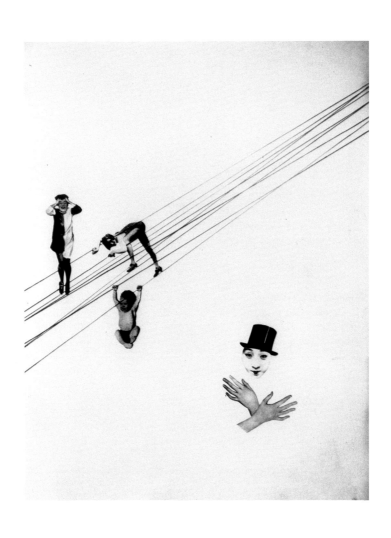

PLATE 3 1

PLATE 3 2

The Eccentrics II

1927

The Eccentrics III

1927

Gelatin silver print
of a photomontage
22.1 × 15.7 cm
84.XM.997.14

Gelatin silver print
of a photomontage
21.3 × 16.2 cm
84.XM.997.27

At first glance these two works are quite different, but they are linked by their dark, menacing character. In both pictures, humans are shown as vulnerable beings under threat by outside forces. The titles suggest the outcast status that many artists were beginning to feel in the increasingly intolerant political climate of Germany. In *The Eccentrics II,* ferocious if commonplace animals attack a tall structure whose occupants are protected by bars. Jeannine Fiedler has suggested that the building may represent the Bauhaus Prellerhaus, with its playing field in front. It is perhaps not too far-fetched a notion, given mounting political pressures, that the photograph may express a sense of being under siege. It is hard to judge whether the three figures on the playing field are coming to the rescue, joining the attack, or fleeing; perhaps they simply contribute to an overall sense of urgency.

The three cylindrical enclosures in *The Eccentrics III* echo the three windows in *The Eccentrics II* but offer no refuge for their inhabitants. One figure is flayed, standing exposed and threatened by a woman with a rifle. Above him, a man takes aim with a pool cue at an unsuspecting huddle of athletes. These actions are apparently sanctioned by the military official who presides over the composition.

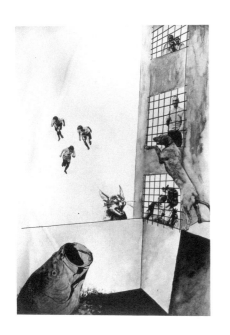
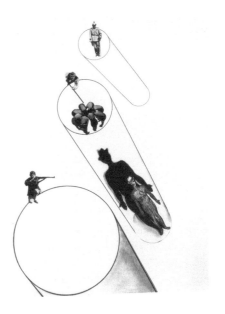

PLATE 33

Up with the
United Front

1925–30

Gelatin silver print
29.9 × 40.4 cm
84.XM.997.67

This documentary-style photograph is
unusual in Moholy-Nagy's oeuvre during
this period and may have been taken to
serve as source material for an exhibition
design or commercial project. However,
two large prints of the image exist in the
Getty collection, both bearing the artist's
wet stamp, suggesting that it was meant
to stand alone. The sea of people attending
this rally for the Factory Workers Asso-
ciation in Berlin dissolves into a pattern of
round faces and hats that would have
been of visual interest to Moholy-Nagy.

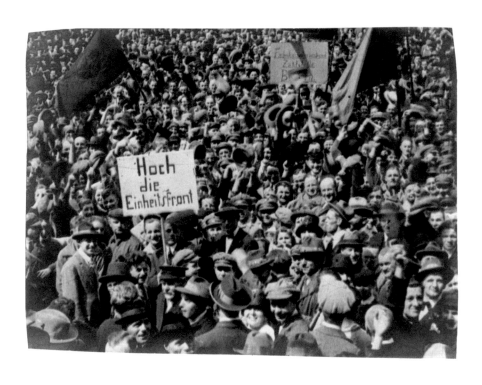

PLATE 34

Photogram

1927

Gelatin silver print
from a photogram negative
23.9 × 17.9 cm
84.XM.997.64

A photogram is a shadowy image made without a camera by placing one or more items between light-sensitive paper and a light source. Lucia Moholy and Moholy-Nagy often took the process a step further by photographing the completed photogram to create a negative or by using the photogram itself as a negative, as in the case of this print. The soft edges of the shapes result from the grain of the paper through which light passed to create the image. This enlargement was made at the Bauhaus in Dessau, where the couple had regular access to darkroom facilities for the first time. The composition has a strong Suprematist spirit reminiscent of Malevich. This picture attests to Moholy-Nagy's belief that something quite beautiful could be created from very simple elements, in this case a rectangle, an oval, and a coil. The flat graphic quality of this piece contrasts with the majority of Moholy's photograms, in which he attempted to convey light and depth.

PLATE 35

Dinghy Being Towed
by a Sailboat

1927

Gelatin silver print
38.6 × 29.3 cm
84.XM.231.5

This particular print, taken on the Wann-
see in Berlin, was one of ninety-seven
Moholy-Nagy photographs shown at the
1929 *Film und Foto* exhibition. It was
subsequently published in Franz Roh's
L. Moholy-Nagy: 60 Fotos (1930), where
positive and negative versions of this
photograph were printed side by side.
Roh called this negative version
an "inversion and enhancement of the
former picture." The print de-emphasizes
the subject in order to focus attention
on formal concerns, such as the play of
light on the surface of the water, in
a way that is related to the photograms.

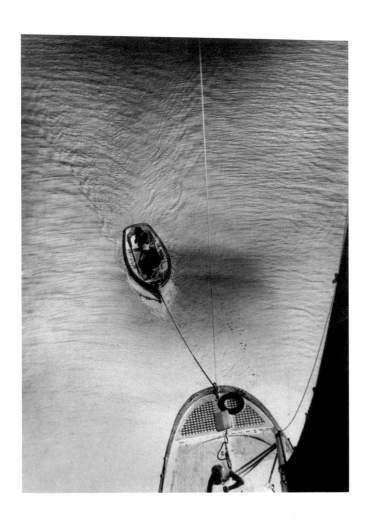

PLATE 36

Photogram

1928

Gelatin silver print
23.9 × 29.9 cm
84.XM.231.3

For a period of time beginning around
1927, Moholy-Nagy placed less emphasis
on painting and instead concentrated his
efforts on photography and writing. In
his 1929 article "Fotogramm und Grenz-
gebiete" (Photogram and frontier zones),
published in the Dutch journal *i 10*,
he declares that the central issue of future
visual creation will be "creation with
direct light," relegating traditional "manual
pigment painting" to a historical and edu-
cational role. With photography the artist
could draw with light, rather than pigment,
on the tabula rasa of photosensitive paper,
as described in his 1928 essay "Photog-
raphy Is Creation with Light." This joining
of science and art is particularly magical in
this composition, in which the floating
forms radiate against the velvety darkness.

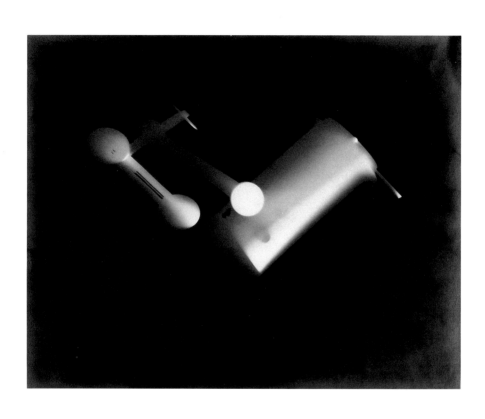

PLATE 37

Photogram No. 1-
The Mirror

Circa 1928 print
from a 1922–23 photogram

Gelatin silver print
63.8 × 92.1 cm
84.XF.450

An early photogram was probably used
as a negative to print this imposing en-
largement, which may have been made for
the 1929 *Film und Foto* exhibition in
Stuttgart. The artist sometimes exhibited
his paintings and photographs together,
and a print of this size would have com-
manded equal attention in such a context.
The title refers to a mirror; it is possible
that the shapes in this composition
were made with a circular looking glass
and its reflections. In his essay "Light:
A Medium of Plastic Expression," pub-
lished in the American avant-garde
periodical *Broom* in 1923, Moholy-Nagy
specifically refers to the use of lenses,
mirrors, and other translucent objects
to create gradations of light values rather
than simple silhouettes. Of all his pho-
tographic work, this print perhaps
achieves most fully Moholy's goal of non-
objective expression and is closest in
spirit to the abstract paintings of Malevich.

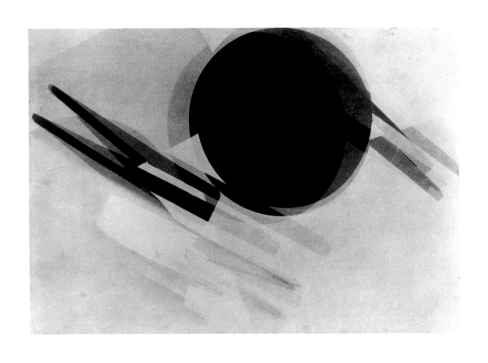

PLATE 38

City Lights
Circa 1928

Gelatin silver print
of a photomontage
30.1 × 23.4 cm
84.XM.997.58

The German avant-garde harbored a great enthusiasm for American cinema, particularly the work of Charlie Chaplin, whose "clown-spectacles" appealed to Moholy-Nagy. Here the Little Tramp figure, taken from a film still from Chaplin's 1928 movie *Circus,* stands on tiptoe and peeps into a mechanical contraption that projects a series of trapezoidal light rays. At the top of the composition, two smiling women in bathing costumes are apparently enjoying their vantage point. In the original montage at the Bauhaus-Archiv in Berlin, the rays are painted in colors and the figures are halftone reproductions from popular magazines.

Moholy-Nagy's involvement with film began in the 1920s, when he promoted the medium as perhaps an ideal one for modern creative expression. He may have felt an affinity with the wordless yet eloquent medium of silent film, since his own work relied on the viewer's visual literacy. It is possible that he gave this work its title after the release of Chaplin's 1931 challenge to the talkies, *City Lights: A Comedy Romance in Pantomime.*

PLATE 39

Double Portrait
of Gret Palucca
1928

Gelatin silver print
of a photomontage
18.5 × 13.4 cm
84.XM.997.21

Gret Palucca was a modern dancer cele-
brated for her athleticism and dramatic
improvisational style. In 1924 she married
Friedrich Bienert and through him became
acquainted with the Bauhaus community.
The same year, she opened a school in
Dresden to train teachers and gymnasts.

Like theater, dance was considered
a medium with great potential for new
expression. Palucca was described as a
"dance artist"; she was celebrated by many
artists and writers and often photographed
in midair. Moholy-Nagy pictures her at
rest and doubles her image by pasting to-
gether two photographs, creating a Siamese
twin effect. For someone as concerned
with motion as Moholy, this is a curiously
static treatment.

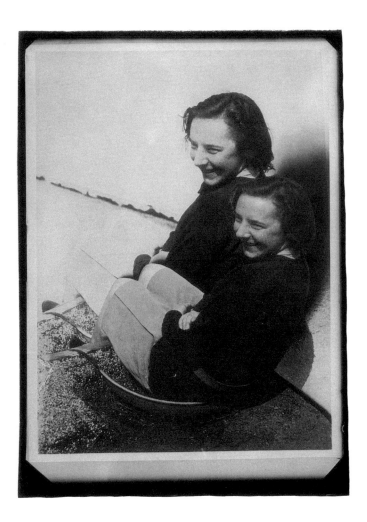

PLATE 40

Cover Design for a Housing Development Prospectus

1929–30

Gelatin silver print
of a photomontage
18.0 × 20.8 cm
84.XM.997.38

This piece was designed as the cover of a prospectus for a large housing development on the outskirts of Berlin. Residents could rent to own their apartments and could have space for a garden. The original montage from which the photograph was made is in the Getty collection.

In this vision of plentitude a smiling man sits on a bench, displaying a healthy armload of children, with a crib of docile infants at his right. Behind his left shoulder is a small picture of the latest in working-class housing, the complex of space-efficient homes and flats being advertised. More prominent in this composition—which is significantly more image-packed than most montages by Moholy—are the abundant gardens and elaborate manors, which, although beyond the means of the average worker, were intended to suggest the pleasures of home ownership. In the 1929 essay "Az ember és a háza" (Man and his house) in *Korunk* (Our time), Moholy-Nagy notes the dire shortage of housing in Germany at this time and urges attention to the planning of apartment buildings so that the interior spaces could perform a more stimulating function than simply protecting dwellers from the elements. Walter Gropius was involved in the planning of the housing development and probably commissioned Moholy to design the prospectus cover.

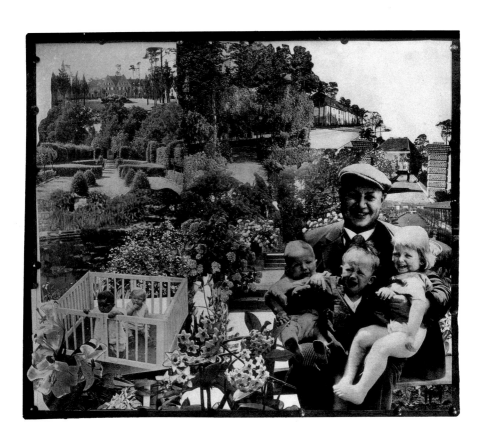

PLATE 41

Be Responsible!

Circa 1930

Gelatin silver print
of a photomontage
13.5 × 18.9 cm
84.XM.997.26

In 1928 Moholy-Nagy left his teaching position at the Bauhaus in Dessau upon the resignation of director Walter Gropius. Returning to Berlin, where he had first lived on arriving in Germany, he supported himself by working as a freelance designer. This piece is probably a design for a book jacket. The use of the script typeface is seen in other examples of his work from this time and represents a departure from the stark, lower-case type he favored at the Bauhaus. Pictures of part of a woman's face are intercut with a variety of crowd scenes, punctuated with the command, "Be responsible!" This piece is clearly a call to action, although the cause is not yet identified. The beginning of the 1930s in Germany was marked by political turmoil and an increasing polarization in cultural and political life. Economic pressures and the threat of censorship presented increasing difficulties for artists. The crowd scenes suggest protest demonstrations; the woman's mouth may represent the importance of speaking out, although it appears oddly glamorous.

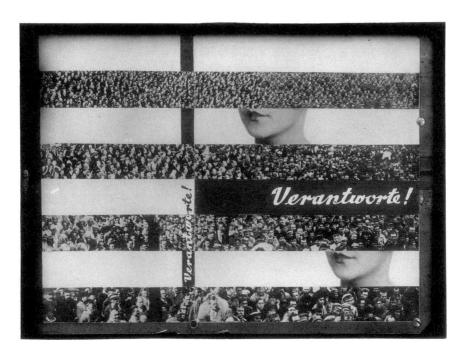

PLATE 42

Light-Space Modulator

1930

Gelatin silver print
24.0 × 18.1 cm
84.XP.912.2

PLATE 43

Light-Space Modulator

1930

Gelatin silver print
23.9 × 18.1 cm
84.XP.912.3

PLATE 44

Light-Space Modulator

1930

Film still from
Lichtspiel schwarz-weiss-grau
(Light display black-white-gray)
Gelatin silver print
11.0 × 16.6 cm
84.XM.231.1

The *Light-Space Modulator* is the most spectacular and complete realization of Moholy-Nagy's artistic philosophy. Machine parts and mechanical structures began to appear in his paintings after his emigration from Hungary, and they are also seen in the illustrations he selected for the 1922 *Buch neuer Künstler* (Book of new artists), which includes pictures of motorcars and bridges as well as painting and sculpture. Many contemporary artists incorporated references to machines and technology in their work, and some, like the Russian Constructivist Vladimir Tatlin, even designed plans for fantastic structures, such as the ambitious *Monument to the Third International*, a proposed architectural spiral of glass and steel with moving tiers and audiovisual broadcasts.

In the *Light-Space Modulator*, Moholy-Nagy was able to create an actual working mechanism. Although he censured capitalism's inhumane use of technology, he believed it could be harnessed to benefit mankind and that the artist had an important role in accomplishing this. Moholy had made preliminary sketches for kinetic sculptures as early as 1922 and referred to the idea for a light machine in his writings, but it was not until production was financed by an electric company in Berlin in 1930 that this device was built, with the assistance of an engineer and a metalsmith. It was featured at the Werkbund exhibition in Paris the same year, along with the short film *Light Display Black-White-Gray*, made by Moholy-Nagy to demonstrate and celebrate his new machine.

The *Light-Space Modulator* is a Moholy-Nagy painting come to life: mobile perforated disks, a rotating glass spiral, and a sliding ball create the effect of photograms in motion. With its gleaming glass and metal surfaces, this piece (now in the collection of the Busch-Reisinger Museum at Harvard University) is not only a machine for creating light displays but also a sculptural object of beauty, photographed admiringly by its creator.

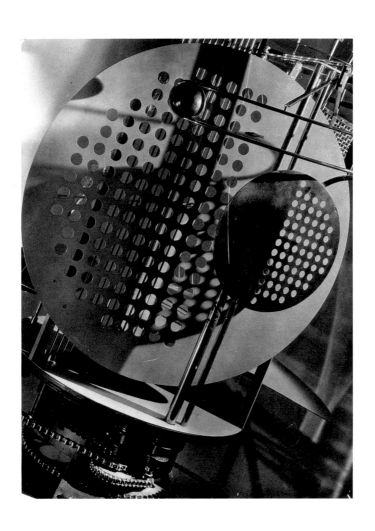

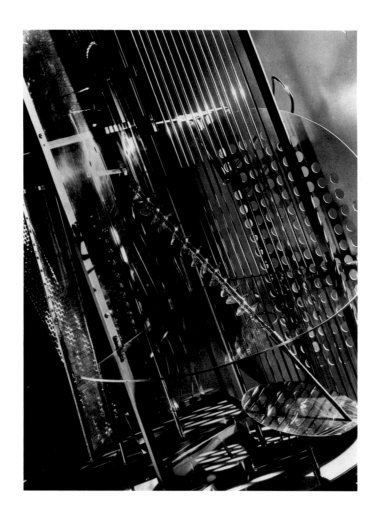

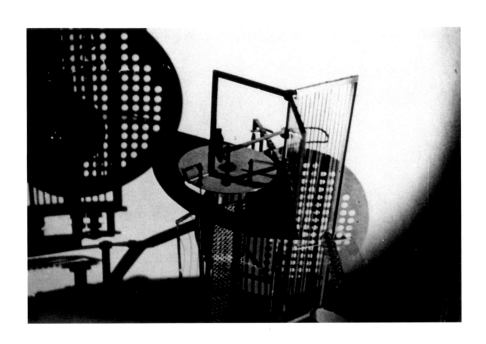

PLATE 45

Norway

1930

Gelatin silver print
25.2 × 20.4 cm
84.XM.997.69

Moholy-Nagy made many of his camera
images while traveling in Europe on vaca-
tion. This picture was taken during a
trip to Scandinavia with the actress Ellen
Frank, who was Walter Gropius's sister-
in-law. In addition to visiting Norway,
Moholy-Nagy also made stops in Finland
and Sweden. His eye was undoubtedly
attracted to the strong diagonals of
the boards and ropes of this structure for
drying fish. The beheaded animals are
difficult to identify and thus become
fascinating forms in an abstract composition.

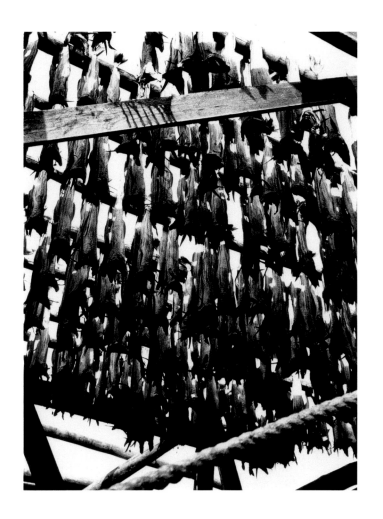

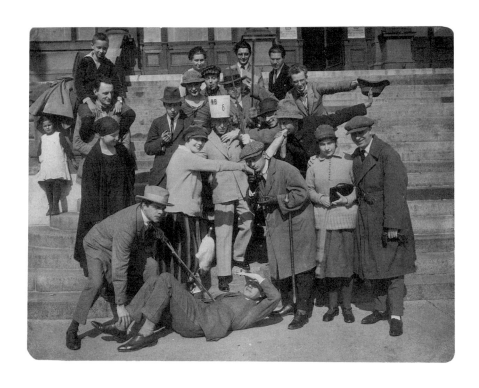

Photographer unknown.
International Dada-Constructivist Congress, Weimar, Germany, 1922.
Gelatin silver print, 16.6 × 21.5 cm.
90.XM.98.3.
Moholy-Nagy (in a dark suit) is at the rear right.

The Vision of László Moholy-Nagy

Katherine Ware: Hattula, you pronounce your last name differently than the rest of us have been pronouncing your father's name—you're saying "Moholy-Nagie" rather than "Moholy-Nawdge." Could you tell us about that?

Hattula Moholy-Nagy: Well, I am sometimes corrected about it! The Hungarian pronunciation is "Mo-hoy-Neug." Hungarian is a very logical language—its orthography follows its pronunciation, but it's different from English. So when we came to this country, we settled on the mispronunciation "Moholy-Nagie." It doesn't really matter, though, because either way it's a mispronunciation.

KW: Not only do we mispronounce his name, we also call him by a name he chose for himself!

Weston Naef: Moholy-Nagy was born in Hungary but spent most of his life in other countries. In 1920 he arrived in Berlin, and his studio became a meeting place for other artists, such as Raoul Hausmann, Hannah Höch, Hans Richter, Werner Gräff, and El Lissitzky. About that time he met Lucia Schulz, a Czechoslovakian woman who became his first wife. In 1920 or 1921 he created an extraordinary collage that is now in the National Gallery of Berlin. In this work he did manually, with scissors and paste, what he would later do with the camera. But what's really important is the content of the collage. It combines machine and industrial forms, like manufactured goods and steel products; it has images of levers and girders joined by a linear

network that is punctuated by applied scraps of paper. It reflects the prior work of Hannah Höch, Alexander Rodchenko, Kurt Schwitters, and Varvara Stepanova.

So by 1921 he had absorbed work that he had seen and produced something that was both original and part of his own artistic spirit. At this point he wasn't interested in photography. So far as we know, he'd never looked seriously at a photograph. However, he soon began to express an interest in photography with Lucia. And the first works that he published were not camera images, but photograms, true?

Charles Hagen: There's a sense of him springing full blown in 1921 or so into all of these different ideas.

HM: Yes, he was working in different media that complemented one another.

KW: Let's begin by looking at two pictures taken by Moholy-Nagy in Ascona, Switzerland, in 1926 or 1927. The first is a portrait of Oskar Schlemmer (pl. 24). A related image is *Puppen* (Dolls; pl. 25), taken on the same day in the same location. Two additional variations on this composition are known: one is of Schlemmer's two daughters, also reclining on the balcony, the other is of just one doll.

WN: We are starting at a point after Moholy-Nagy began to work in photography. The photograph of Schlemmer gives us a chance to discuss the background of Moholy's work and teaching, particularly during the period in which the Getty's collection of his pictures is strongest, 1923 to 1930.

Jeannine Fiedler: Moholy and Schlemmer first met at the Bauhaus, where they were both masters. Moholy was invited by Walter Gropius to join the faculty in 1923, as head of the metal workshop. Schlemmer had been teaching there for several years as master of the sculpture workshop and later of the theater workshop.

KW: Moholy-Nagy and Lucia visited Schlemmer and his wife, Tut, in Ascona during several summers, so it is difficult to determine which year these pictures were taken. On the back of the print someone has inscribed, "Balkon der Casa Fantoni," so we know it was probably taken on a balcony at a place called Casa Fantoni.

Leland Rice: Here he's dealing with almost a private space. He's moved close to Schlemmer, who is extremely relaxed. It looks like he's lying on a bath towel; maybe they were going on a picnic or to the beach.

JF: For me, the most interesting aspect of these photographs is the way the grid structure of the balcony becomes completely independent and is superimposed on the subjects. It's typical of the photographs Moholy took after he got his first camera.

LR: In the early 1970s I corresponded with Lucia Moholy about the casual quality of both the poses and the people in Moholy's photographs. She said that when they were together, Moholy never went out planning to make photographs. But invariably, when small cameras became popular, by the mid-1920s, everyone had one slung around his shoulder.

HM: He was happy to have a portable camera, and he took it with him on vacations. The Bauhaus group often vacationed in Ascona. He composed his pictures in the viewfinder, and they show all the typical traits of Constructivist images—the diagonal composition, the overhead point of view, the use of the grid.

JF: These two pictures show the Constructivist background of Moholy—throughout his life he called himself a painter rather than a photographer. I think the subjects are not as important as the structure.

KW: Let's define what you mean when you talk about his work being Constructivist.

Thomas Barrow: One of the central characteristics of Constructivist art was the use of bold, dynamic diagonals, and certainly we see that here. I think Moholy understood the way these slashing diagonals gave energy to the two-dimensional surface.

CH: I see the figures of Schlemmer and the dolls as related to the Dadaist figures in Hannah Höch's collages. In that sense they look forward to the *fotoplastiks,* the combination photos Moholy did later.

WN: Right. But the real question is what role Dadaism plays in the *fotoplastiks.* Moholy's work clearly has less sarcasm than the biting, lethal edge of Dadaism. The dolls themselves are so soft, so rubbery.

JF: The doll pictures are really funny.

KW: They're Surrealist.

JF: The two dolls may be stand-ins for the Schlemmers' children. These must have

been their dolls, in fact. Usually if you have an image of dolls, it has morbid or surreal overtones, as Kate suggested. But I don't see that here. This has more of a humorous touch to it.

KW: But one doll has no legs.

CH: I don't find them soft. One of the dolls has its head thrown back as if it's dead and has no legs and one arm broken off. It's interesting to actually take his subjects seriously sometimes and try to understand why he chose to photograph certain things.

KW: He's playing with the location and the figures and the grid in all four related exposures made in Ascona. Obviously it was of real interest to him. The Schlemmer picture, for instance, is a portrait, but Moholy is as interested in the light as he is in Schlemmer.

LR: These pictures incorporate ideas and issues that Moholy continued to pursue for many years—the use of different textures, the importance of shadows as formal elements. This leads to the idea of depicting the play of light.

HM: The composition is just like that of his photograms from that period, the late 1920s. The focus on structure rather than content is very important in all of Moholy's photographs. In the photograph of the dolls, especially, the shadows make the composition; the dolls are almost incidental.

KW: It's interesting to consider these images in the context of the photograms. There's a similar sense of forms being laid onto one another.

LR: This is the whole point of some of his photographs, I think—that they lead right into his photograms and his paintings.

The play of shadows across the two dolls seems completely arbitrary. The legs of the one doll extend the checkerboard effect of the shadows, but all the other shadows can be accounted for. I don't think he's trying for any deep psychological meaning by suggesting, let's say, that the shadow in the upper-right-hand corner is somehow ominous.

CH: It seems as though time has passed between the two pictures—the shadows have moved.

TB: These are not images that I think of as typical of his work. They betray the influence of Constructivism, but they remind me of Werner Gräff's work, or that of other people photographing at the time. In *Foto-auge: 76 Fotos der Zeit* (Photo eye: 76 photos of the period), which was published in 1929, there are at least four photographs of dolls. In other words, the doll was a common object in photography then. Beaumont Newhall was talking about this picture when he did the *Photo-Eye of the 20s* exhibition for the Museum of Modern Art in 1970. He said that this was the period in Bauhaus photography of "looking up, looking down." There's a lot of that in Werner Gräff's 1929 book *Es kommt der neue Fotograf!* (Here comes the new photographer!), where there are photographs with high and low vantage points. This kind of photography was in the air.

WN: I disagree, Tom. I think of these as quintessential Moholy-Nagy images. I have never confused these pictures with the work of anyone else, even with perhaps their closest siblings, the pictures Alexander Rodchenko was making in Moscow at the same time.

I think the reason these have left such a strong impression on me has to do with the combination in them of figuration and abstraction. In these photographs Moholy does what many artists after him tried to do, which is to lay an abstract grid onto a figurative element. He has chosen two kinds of figures: the dolls, and Schlemmer, who was perhaps the most influential person in his life up to that point, a powerful force. Aside from Walter Gropius himself, no one at the Bauhaus was more influential.

KW: I don't agree that Schlemmer was the most influential person in Moholy's life. They were friends, but there was also friction between them. Schlemmer was a lot more conservative artistically and felt displaced by abstractionists like Moholy. This portrait, to me, gets to the heart of what Moholy was trying to do: it's about abstraction, but it's also grounded in the real.

JF: Moholy may have influenced Schlemmer, rather than the other way around. Various scholars have argued that Schlemmer gave up painting because of Moholy's influence and through his emphasis on bringing technology to the arts.

LR: Yes, it's astounding how much Moholy brought with him to the Bauhaus. György Kepes is very clear about that.

KW: That's right. Moholy came to the Bauhaus when he was twenty-seven years old, and he had already absorbed a lot of information from the Hungarian avant-garde journals.

WN: He brought something with him—the benediction of genius. But let's not forget where the influences for the abstract tendency would have come from. In 1922 the *Erste Russische Kunstausstellung* (First Russian art exhibition) took place in Berlin at the Galerie Van Diemen, where Moholy saw for the first time Lissitzky's *Proun* series of lithographs, which were pivotal for many of the non-Soviet artists in Germany as a demonstration of what abstract art was about.

My impression is that many of the people at the Bauhaus also saw this exhibition and were aware of the origins of the style. So at that point Moholy was a follower rather than a leader, in terms of abstraction. In 1923, when he arrived at the Bauhaus, he was already a purely abstract artist in the mold of Rodchenko, Kasimir Malevich, and El Lissitzky.

CH: He obviously came to Berlin with an open mind, eager to take in everything he saw.

TB: When Moholy left Hungary, he didn't go directly to Germany; he went to Vienna.

JF: Moholy's biggest influence in Hungary had been Lajos Kassák, the Hungarian Constructivist and leader of the group centered around the periodical *MA* (Today). But Moholy couldn't stay in Hungary, because there were political problems. So he fled to Vienna and in January 1920 moved to Berlin, where he became part of the Dada circle, with Raoul Hausmann, Hannah Höch, and so on.

WN: These two photographs, of Schlemmer and the two dolls, seem to have abandoned Dadaism as the underlying thread. So he used the camera to release himself from what up to that point had been one of his dominant influences.

TB: I think the primary influence was actually Wassily Kandinsky.

WN: Kandinsky has to be considered as a background figure. The problem is that

Kandinsky was not regarded very favorably by other artists, and his work wasn't widely seen.

KW: Kandinsky was already at the Bauhaus when Moholy arrived.

JF: I think when Moholy entered the Bauhaus he became the leader, the enthusiastic proponent of all these new ideas. And older painters like Lyonel Feininger and Paul Klee were very anxious about this young man coming from Berlin with his head full of fantastic ideas, really charging forward.

TB: Weston is correct that there wasn't a great retrospective of Kandinsky's early work that Moholy could have seen. But there were reproductions, and Kandinsky taught at the Bauhaus. I have always felt that he was aware of Kandinsky's explorations of the nonobjective. I can't see anybody else that he would have come in contact with who would have done this for him.

CH: But before this time he was already deeply devoted to abstraction. And in those years, many people were working toward abstraction in different ways, not simply as a way of separating the image from the real world but also as a way of seeing new worlds or pointing to the spiritual.

LR: The thing that intrigues me about Moholy is that even though he had already made some nonobjective pictures, when he picked up the camera he didn't try to use it as a nonrepresentational instrument. As Weston suggested, he was trying to overlay nonrepresentation or abstraction onto a representational image. Almost nobody in photography at the time tried to use the camera as a nonrepresentational device, and Moholy didn't either, even though he'd already experimented with photograms, which were, for him, totally nonrepresentational.

CH: But these pictures are definitely not ordinary photographs. I have always thought of this picture of Schlemmer as a snapshot, basically—they're having a nice time on vacation, playing around with the new camera.

JF: We haven't really talked about Moholy's use of perspective in these pictures. He always wanted to create a dynamic spatial structure in his camera work. The spectator can experience something like vertigo, being pulled into the space that he describes.

CH: Moholy is playing with perspective in a way that, at the time, was not an accepted use of photography. The Schlemmer portrait is a classic photographic "mistake," to have the huge feet, the tiny torso, the tiny head. It becomes a caricature, which many other people worked with then and also afterwards. But it is not a straight photograph.

WN: Unlike most of the other artists of his time, Moholy apparently started with photograms and moved to camera photographs. So this is a kind of reading out with the camera of forms and subjects that he had already explored in photograms.

LR: By the time he made these photographs, Moholy had already been making photograms for four or five years—pictures of objects placed on paper and exposed to light, which were more in keeping with his paintings of the period. So these rather sophisticated camera images have several years' worth of development behind them. His transparent painting period, which was roughly 1921 to 1923, corresponds with the beginning of his interest in photograms. In *Abstract of an Artist* (1947) he said that he was trying to detach his paintings from "elements reminiscent of nature."

KW: Yes. The back of *Photogram* of circa 1924 (pl. 2) carries an inscription by Moholy-Nagy in which he identifies the objects used to make the image, but then he says that's unimportant, that his emphasis is on how the light flows, on making the picture transcend the elements of its creation.

LR: He said about the early paintings that "the liberation from the necessity to record was their genesis. I wanted to eliminate all factors which might disturb their clarity, in contrast, for example, with Kandinsky's paintings, which reminded me sometimes of an undersea world." That's also what he strives for in photography.

JF: An important point about the photograms is that in the process of making them, the light is working for the artist, which is exactly what Moholy wanted to achieve when he was called to the Bauhaus by Walter Gropius.

KW: Let's turn our attention to one of the photograms, *Photogram No. 1-The Mirror* (pl. 37). We think the photogram was made in 1922–23 and that this print was made from it around 1928.

CH: This is really an extraordinary object. It's very large. How was it made?

WN: In their 1922 article "Produktion-Reproduktion," Moholy and Lucia described how they made the first photograms by creating images on film without a camera by using a mirror or lens devices. It seems to me that this method was used to make this picture, because it is a positive rather than a negative. The process would have been quite different from Man Ray's photograms from the same period.

From looking at the print we can guess that it was created as a negative on a transparent base, because of the white background. If it were created in any other way, it would have a dark background. But if a photogram, a cameraless picture, were made on a transparent base and then put into an enlarger and projected to get it to its present size, all of the tones would be reversed, with the whites becoming blacks and the blacks, whites.

TB: It's an extraordinary image. It's really one of the great Moholys. The scale has something to do with it. It is the largest one I have ever seen. It also says on the back "Mirror," so that reinforces Weston's comment.

Having made a lot of photograms in my career, I have found that it is very difficult to work on film. I think it was probably made on paper and was a negative photogram that was then placed face to face with another piece of photo paper and exposed again to make a positive. I think it was then photographed and the enlargement made from the negative. The middle tone in the circle has stayed very sharp, but on the right side there is softening, which makes me think it's from a copy negative.

WN: What are the original objects that created these shadows? They seem to be cut paper. These are not the sort of objects taken from real life that Man Ray was using. These elements are so dematerialized that we can't imagine that this is a bowl sitting on a piece of paper.

TB: Let's think about the differences between Moholy's work and Man Ray's. Man Ray, although he said he did not like being called a Surrealist, did use objects in a surreal way. He always wanted the objects defined. But Moholy was, as he said, sculpting or painting with light.

JF: I think that with his photograms Man Ray wanted to create mysterious glowing objects, a world of enigmatic objects. And that's completely contrary to what Moholy

wanted to achieve. He worked with cutout paper templates, little strips of board or paper, and he used very cheap photo paper for his photograms, which Lucia called *Auskopierpapier* (printing-out paper). It was very thin and had a brown tone.

WN: Is it possible that he created a negative photogram on this very thin paper, then printed the negative in contact with another sheet of paper? This is such a good picture that if they had a negative of it, why wouldn't they make another print? This is the only surviving example.

JF: The inscription on the back of this print suggests that they made it for an exhibition, possibly *Film und Foto* in Stuttgart in 1929.

WN: But of all of the other people who made photograms, only Christian Schad persistently created unique objects. Man Ray rephotographed his photograms, and they exist in multiple copies. Here is Moholy's greatest early work! If he used a negative to create it, it seems highly improbable that he would not have made another print at some point!

KW: But I don't think he was interested in repeating himself. Once the experiment was finished, he moved on to the next one.

LR: When Moholy did these photograms, he did many, many variations.

JF: It's kind of misleading that this is called *Photogram No. 1*. It could mean that this is the first photogram for an exhibition.

KW: Right. There are variations on this photogram that were reproduced in European avant-garde journals. It may be "number one" of the variants.

LR: When you're in the midst of discovering how you want to make a series of photograms, using objects that transmit light, you would rarely ever do just one and say, that's the one. Particularly Moholy. I think his work procedure was to discover through the process of the activity of making numerous photograms, moving the elements around, pieces of paper. I have seen at least four variations on this same series of motifs. I think this particular image is unique, but enlargements of other images do exist.

JF: He used a positive version of this in Chicago for a Christmas card.

TB: I never have understood what they meant by a mirror. How would you use a mirror in this photogram?

JF: Maybe Lucia was mixing up the form, the shape of the mirror, and she didn't really mean the reflections.

LR: I would suggest that if the elliptical shape is not a mirror, it is a glass element. As you know, Moholy was extremely interested in objects that would transmit light. That's what his paintings were moving toward, as well as his photograms. What about the possibility that in this image the light is not coming from overhead but rather is being projected through glass objects of some sort, standing on edge, and that the light in this global area, which is of different gradations, is coming from the side?

TB: Well, I think the light comes from more than one source. In many photograms Moholy used glass objects. If you use a raking light, the refractions of the glass will print.

JF: But the forms are not like the clear-cut shapes you have in this photogram. I don't think he used glass. It wouldn't give the right form.

CH: In the article "A New Instrument of Vision," from 1932, published in English in 1936, Moholy calls the photogram "the real key to photography," and says it's "the most completely dematerialized medium which the new vision commands." I think that's a crucial point: it's not about something physical, it's about light. Whether it's through glass or through an object or through cut paper is almost irrelevant. The light was crucial to him.

JF: I'd like to add another quotation, from the Bauhaus journal of 1926. This is my translation: "The optical miracle of the black-and-white transposition in photography should generate out of the light, without literary secrets or associative connotations. . . . All secondary imitative elements, even reminiscences to them, should be eliminated."

WN: I think this picture is totally supported by that text. I believe this is from cut

paper. These forms are flat, dematerialized. There is no suggestion, as there often is in Man Ray's work, of a beaker or keys or a comb. This is what distinguishes Moholy's work of this period from that of Man Ray, and even Schad.

LR: In regard to the subtleties of the photogram, this is a passage from *Vision in Motion*. Moholy writes about the unique characteristics provided by photography: "The ability to record with delicate fidelity a great range of tonal values allows the photogram to exploit the unique characteristics of the photographic process. The almost endless range of gradations, the subtlest differences in grain, belongs to the fundamental properties of photographic expression."

TB: That reminds me of why I was drawn to photograms in my own work. I found there were many more possibilities in the photogram than in camera imagery. But a sad thing I learned about Moholy-Nagy was that he duplicated his photograms. I was so inspired by that particular quotation, and others, that I wondered why he would ever make a copy negative.

WN: Were you concerned that a copy negative fails to achieve a living presence of the light on the paper? A print from a copy negative of a photogram seems to me much less authentic even than a print from a negative of a copy negative of a study from nature.

LR: They were doing it for a very simple reason—the reproductive potential of the medium. To exhibit the work is one issue. But at the same time, there's a very simple situation they had to face: "It's unique. I'm not going to send that off if somebody asks to reproduce my work."

TB: But to me it was so exciting to make this unique object that flew in the face of the idea of photography as an infinitely reproducible medium. There is a certain mystical feeling to letting an object describe itself.

WN: I think the reason he made copies of the photograms is a simple one and has to do with El Lissitzky's approach to photography. Lissitzky started making photographs when he was in a sanitarium in Switzerland, because it was the only way he could share his visual ideas with his friends back in Moscow. I think that Moholy, too, must

have wanted to share his visual ideas with his friends, and so he had to reproduce them in some way.

JF: I think earlier you hit on a very important aspect about his personality. It's one thing to create these unique pieces, but it's another thing to promote your ideas and to disseminate your ideas and theories.

KW: Which is really the focus of everything he tried to do.

JF: I think he was always interested in that. He had both sides to his personality; he was both an artist and a teacher.

CH: We've talked about Moholy's interest in dematerializing the object, dissolving it into pure light. But at the same time, he was also very active in using lots of new materials in paintings and sculptures. He worked with lots of patented composites, metal, plastics of different sorts; he was very interested in nontraditional art materials.

TB: Moholy is a difficult artist. He has not received the attention other artists have, because the status quo is hard to break, and there still is a real tradition of craftsmanship. My painter friends still use brush and canvas, and they still use oil paint.

I find Moholy, much of his thinking, so accessible today, and so prophetic. There are so many contemporary things that he predicted.

An American artist who is very similar to Moholy in some ways is Frank Lloyd Wright, who said, "Tear down the past." He wanted to break down the traditional artisan's way of working. He started designing ornament in Louis Sullivan's office, but he came to use the most modern materials in his own buildings. When they restore some of them now, they have a rough time, because he used some of the newest kind of laminates and aggregates, and they can't replace them today. But much like Moholy, he was attracted to the newest materials.

Somebody I've been reading a lot lately, because he influenced the French theorist Jean Baudrillard, is Marshall McLuhan. And McLuhan's writings often sound like Moholy's.

JF: Yes. I gave a talk a few weeks ago comparing *Vision in Motion* to *The Medium Is the Massage*. Moholy's book is really the foundation of what McLuhan wrote twenty years later.

TB: One of the few photographers Walter Benjamin mentions in his writing is Moholy. I think they shared similar ideas about the aura of artworks and about their reproduction. He was prophetic—I think that's the word for Moholy. There aren't many prophetic artists. Picasso, for all his greatness, didn't prophesy. We are looking at these works, and I think they're important. But what do you think about Moholy's theories? Do they overpower the work?

CH: As you mentioned, some people don't regard him as a great artist. I think almost everyone acknowledges that he was an extremely important force in modern art in the 1920s and 1930s. To my mind he is the prime proselytizer for Modernism in art.

TB: I agree. I think he is one of the key Modernist figures. Modernism would be a very different thing, I think, if he had never lived. But where do we place the art? I don't think it's a body of work to hold up against the work of Matisse or Picasso. But that doesn't mean I don't think he's important.

JF: We haven't discussed the complex marriage of art and technology that both Gropius and Moholy advocated. Before they came, there was an Expressionist period at the Bauhaus in Weimar. Moholy brought this whole technical aspect to the curriculum and ideology of the Bauhaus. He wanted to dissolve the tradition of craftsmanship—of artists working with their hands—and to make this kind of work obsolete.

KW: Which is why the camera was so appealing to him, and film. That the machine would make the picture, and after making a print it could be reproduced mechanically.

JF: Another example would be his legendary "telephone pictures." The story goes that he just called an enamel company in Berlin and ordered paintings by telephone. That's the ultimate expression of this idea of anticraftsmanship.

CH: I want to compare Moholy's *Light-Space Modulator* pictures (pls. 42–44) with Paul Strand's images of the interior of his Akeley motion picture camera. Both groups of pictures have the same awareness of the interaction of geometric forms, and both use the play of light on metallic surfaces.

JF: I think it is strange to look at these pictures of the *Light-Space Modulator* as pho-

tographic art. This machine was meant to be seen in motion, projecting light onto the surrounding walls, and you cannot see that in a picture. It would be better to look at the film of it, *Lichtspiel schwarz-weiss-grau* (Light display black-white-gray).

KW: But look at how he photographed this. It is a beautiful object in and of itself, a sculpture.

CH: The one on the left in particular (pl. 42) I could read as a photogram.

LR: Did this machine survive?

JF: Yes, it's in the Busch-Reisinger Museum at Harvard. Two replicas were also made. But you can only get the full effect of it if it's in motion.

TB: If you accepted that argument, though, you could never photograph an automobile or an airplane or anything else that moves. If this photograph were simply a document, he would have backed away, and the object would appear totally vertical, sitting on a pedestal. He gave these pictures as much dynamism as he could.

JF: He came up with the idea of creating this sort of machine in the early 1920s. He was already thinking of making something like a kinetic sculpture.

LR: But when was this one physically realized?

JF: In 1930. By then he had left the Bauhaus and was working in Berlin.

TB: Did he know about the light organ that was connected with Aleksandr Scriabin's music?

HM: Yes. He was fascinated by all those things and had descriptions of light organs.

LR: When he was in England did he know of Francis Bruguière, the photographer who was working there at the time? He was also interested in stage design and light organs.

HM: I don't know.

LR: Bruguière comes to my mind as the only other artist-photographer who worked with similar ideas, using light as the primary agency of exploration.

KW: The *Light-Space Modulator* recalls Kurt Schwitters's ideas about the *Gesamt-kunstwerk,* the total art object. It's a sculpture, it makes light patterns, you can use it in theater, you can photograph or film it.

CH: I'd compare it to Jean Tinguely's self-destructing machines of the 1960s, which indicate how much attitudes toward machinery had changed by then.

These pictures point to something else as well—the split in Moholy's thinking and work between his love of machines and industry, which I tend to think of as very physical, and his passion for the pure, dematerialized light that comes out of this machine, where it's just a disembodied phenomenon.

HM: I think that's all tied to people's attitudes toward machines in the 1920s. Machines represented a way to a better life. I think Moholy believed that.

WN: Only through photography could Moholy show us exactly how he wanted us to see this piece of sculpture. These photographs would seem to fall into a separate category of art that relates more to Henry Moore's or Constantin Brancusi's photographs of their own sculpture.

JF: You have to see the film!

TB: It's more than that, though. They're not just records of the sculpture.

WN: Oh, absolutely. These vivify and animate the sculpture because of their point of view.

KW: Another kind of photograph Moholy made are the *fotoplastiks,* such as *Der Abschied* (The farewell; pl. 3) from 1924.

CH: This picture brings out the aspect of narrative that he achieves in his collages partly through formal means, like the grids of lines. It's also a very ironic image.

WN: This represents an about-face from the very spare, abstract Constructivist compositions of his photograms and paintings from 1921 and 1922. Here emotion has replaced symbolic light as the content.

CH: But it's a very mannered emotion.

WN: Yes. He's straining for emotion.

CH: One of the interesting things about Moholy is that his works almost always seem so unemotional.

KW: This is jokey, melodramatic, exaggerated.

CH: Alluding to Hollywood perhaps.

JF: This is a very early piece; maybe he was still developing his technique for *foto-plastiks*. The title means "farewell"; with the two people in such exaggerated poses, as if on the stage, it could mean something like farewell to manners, because now we are surrounded by industry, by technology.

CH: I thought of Anna Karenina throwing herself in front of the train—the woman seems about to dive off the bridge.

WN: It's also about popular culture. He's dealing with the machine age on one hand, the machines and trains in the background, and then this quotation from overtly popular culture, a couple doing a kind of burlesque soft-shoe routine. So by superimposing the two subjects, he's turning up the emotional content.

I think this piece looks terrific in reproduction and terrible in the original. It's an irony! Unlike *Der Wasserkopf* (The water head; pl. 20), which looks roughly the same in both the original and the reproduction, somehow *Der Abschied* looks insufficient as a work of art as a photomontage. It's partly because there's so much drawing and painting, particularly in the foreground. This is really about gesture as opposed to line.

KW: How should we define *fotoplastik*? *Plastic* in art suggests shaping and forming; in the De Stijl movement, the term *neoplastic* had to do with bringing together diverse elements to make something new, with a new meaning.

WN: In the visual arts the word *plastic* has traditionally been used to describe something infinitely malleable, infinitely moldable, by the hands or the imagination of the artist. In coining the term *fotoplastik*, Moholy was inventing a word that is essentially an oxymoron. Photography itself is usually thought of as the least plastic, least malleable medium, open to few interventions by the artist.

JF: What's also important is the third dimension. In the *fotoplastiks* he tried to create this sense of depth; this is another meaning of the term *plastic*.

WN: He created these things by mounting photographs or reproductions onto pieces of paper, then drawing on the paper. So the surfaces of the resulting products would not have been homogenous; the montages were handcrafted objects. But in order to keep the integrity of his idea, he needed a totally uniform surface. So copying the original montage was essential to his artistic idea. For those of us who are purists about the subject, there is always the question of whether the montage or the copy made from it is the art object.

CH: An interesting parallel is the exhibition of John Heartfield's work at the Museum of Modern Art in 1993, showing the original montages. It was fascinating for people who already knew his work, because you got to see how he blended images and air-brushed and painted over them, and so on. But they were really contrary to what I think is the spirit of Heartfield's work, which was on the cover of *AIZ* (*Arbeiter-Illustrierte Zeitung*), the workers' magazine, every week.

LR: Many other artists have made collages, and some have made collages in which they didn't actually glue down the individual elements. Therefore, after the photo-graph is made, no maquette remains. Frederick Sommer is an excellent example of that, in terms of his collages from the 1940s and 1950s.

WN: I think it's an interesting question in regard to the relationship between Rod-chenko and Moholy. Nearly all of Rodchenko's original montages still exist. Curators and collectors are divided over whether the photographic copies of Rodchenko's work are the definitive states or whether the original montages are.

LR: I agree. For Moholy, the montage was not the end product. Some of Moholy's original collages do exist, although not many. But they look remarkably different from the copies. Who's to say whether they were ever intended to be exhibited or con-sidered as finished objects? I find them quite enticing.

WN: He clearly did not value the montages as much as he valued the *fotoplastiks,* judging simply by the fact that the *fotoplastiks* are what survive. We have to say, by deduction, that Moholy valued the photographic replica more than he valued the original montage.

LR: Some historians feel that these are nothing more than copy prints.

WN: This becomes a market question; it has to do with the sort of trophy hunting that I think is the worst kind of collecting imaginable, because it assesses value according to the worst possible measuring stick, which is rarity alone.

LR: I think, though, that calling these *fotoplastiks* is a bit of a misnomer. They're photocollages.

WN: Well, it's the same thing as referring to a photogram by Man Ray as a Rayograph. Moholy coined the term, and I think we have to respect it.

TB: I think this is a very important point in terms of Moholy-Nagy as a supreme Modernist. Personally, I like to look at the montages better. In them the pen lines take on greater importance, and I like seeing the mark of Moholy's hand. But we know from Moholy's own writings that the copy was the important thing for him. The idea of the copy fits in with his beliefs about the importance of modern technology and the infinitely reproducible image. I don't think he would care about his own mark being in there. He would probably love working on the computer, because he could make the whole picture on a homogenous surface and have no apparent handwork on it at all. Jeannine mentioned earlier the incident where he may or may not have ordered paintings over the telephone. I think with the *fotoplastiks* he wanted a final product that could be easily reproduced, because that way he could make use of existing technology. The montages were probably of little interest to him, compared to photographic copies like these.

CH: In a 1927 essay entitled "Photography in Advertising," Moholy wrote that the *fotoplastiks* "allow us to depict a seemingly organic super-reality," and then described them as a kind of "super-photography." I find those terms very provocative: "super-reality" because it seems to suggest Surrealism, "super-photography" because it hints at a more insightful, more penetrating form of the medium.

WN: Clearly, Moholy is saying that through the process of photography you get to a higher position, a stronger position. When an artist writes and talks as much as Moholy, you have to take his words seriously and allow them to influence your aesthetic and your value judgments. It's for that reason that I've come to assert the primacy of the *fotoplastiks*.

TB: That's a good point. Obviously, they're meant to be rephotographed; you can see the thumbtacks at the corners of *Der Abschied*. But he would have cropped that out. I used to wonder, when I first saw it, what it was for. You call it a *fotoplastik*, but it doesn't have the conviction of a montage made as a discrete image.

KW: What do you think about *Die Eigenbrötler II* (The eccentrics II; pl. 31) from 1927? There are three very different pictures with this title. The word means an eccentric or a recluse.

LR: This piece is about isolation and incarceration. Moholy has reversed the usual order of things, putting the animals outside, free to roam, while the people are behind bars.

JF: A female *Eigenbrötler* would be a spinster or a crackpot.

CH: A loner.

LR: The animals seem to be menacing, while the people are quietly absorbed in their isolation. The runners are free, outside the building. And is that the finish line in the foreground? You go on and on with interpretations. But the point may be that it's not complete in itself but must be seen in combination with other images, as a series.

KW: And it has to be completed by the viewer with his own associations, Moholy-Nagy might say.

JF: The Bauhaus students lived in a building called the Prellerhaus, and this could be a witty comment on that situation, with all the students in these cagelike structures. Outside the Prellerhaus was a field where the students used to play soccer.

WN: That's a very interesting suggestion. In a vacuum, all we have is our response to the picture. But once it begins to have a connection to another actuality, like student life at the Bauhaus, its meaning changes.

TB: But I think Moholy was very antiliteral. I agree that in some pictures there is an iconography that can be read. But a lot of his images are not meant to be read so literally. You could think of him as one of the first Postmodernists! He's interested in appropriation; he doesn't care about the handmade object.

WN: That's particularly true in a group of images such as *The Law of the Series* (pls. 17–19), where he transforms the image over and over by photographing, rephotographing, printing, reprinting, changing the image with each step.

CH: In *Vision in Motion* Moholy described the series as "the logical culmination of photography."

WN: The Getty collection is particularly strong in series of works that start with the montage and then move into offset reproductions of the *fotoplastik*. For example, we have one set of pictures in which the main figure is a boxer (pls. 7–8). We have the *fotoplastik* version, a hand-colored version, and a third version, a very early halftone offset; this was in the early years of offset technology. That version looks like it was printed from inked bread, the tones are so mushy. But there's something wonderful in watching Moholy stretch to the extremes of experimentation. It's a little like Garry Winogrand photographing things because, he said, he wanted to see what they looked like photographed. With Moholy, it's almost as though he went through this process to see what the image would look like printed differently.

In 1928 Moholy left the Bauhaus along with Gropius and moved to Berlin, where he established a commercial studio and began to work with the State Opera. His studio was large enough that he hired György Kepes as an assistant. So he was no longer an independent creative artist in an ivory tower; he was in an arena where his clients had to be satisfied. One of the boxing pictures (pl. 8) anticipates this; it is clearly an advertisement for a sporting goods store.

LR: Behind the boxer you have four women in bathing suits, a group of men in uniforms with a surveying instrument, and an ominous-looking soldier wearing an armband. What do these people have to do with an ad for a sports shop?

JF: It looks like he started out to make a montage and then later attached the advertisement to it. It would make no sense to have the cheetah in an ad.

WN: So he took an existing image and retrofitted it to another purpose. But does anybody here know whether this was ever used for a commercial purpose?

KW: Lucia Moholy wrote that it was never used.

JF: I think what was fascinating in the 1920s about his first photographs was the kind of speed they showcased—it was the Roaring Twenties. They were about speed, big cities, and a new kind of public formed by advertisements.

CH: And picture magazines, too. That's the period, I think, when you start to get sports heroes as celebrities, from Gertrude Ederle to Babe Ruth.

TB: The rise of picture magazines and rotogravure printing made these images available for photomontage.

KW: The rotogravure magazines became the source material for many artists working in collage and montage, such as in Moholy's *Der Wasserkopf* (pl. 20).

JF: It's interesting that the images of the two divers are by other artists.

CH: And of course the smokestack is a photograph by Albert Renger-Patzsch.

TB: Early appropriation!

KW: One question is how the title should be translated. "Water head," the literal translation, is an insult, a colloquialism for a dope—empty-headed, we would probably say.

JF: The word also has a double meaning, because it refers to the disease hydrocephalus.

TB: I think you always have to explain it. We all know the famous Lewis Hine photograph from about 1924 of the hydrocephalic girl and boy lined up one behind the other in an institution in New Jersey. Until I saw the translation of the title, I never understood this one. I remember from my childhood that "water head" was a colloquial term for hydrocephalics in the Midwest, too.

JF: Renger-Patzsch was the most important exponent of *Die Neue Sachlichkeit*—The New Objectivity; this photograph appeared in his 1928 book *Die Welt ist Schön* (The world is beautiful).

LR: Moholy used the same photograph as an illustration in *Painting, Photography, Film,* along with the caption, "Effect as of animal power in a factory chimney."

WN: Right. He credited Renger-Patzsch in that book, but he didn't here. He's borrow-

ing a picture by one of the two or three most celebrated photographers in Germany at the time, the equivalent of, let's say, appropriating an Irving Penn image today.

JF: Or maybe something by Bernhard and Hilla Becher!

WN: This raises the question of originality in Moholy's work. He was attacked by some Russian artists who felt that he had plagiarized their material. In 1925 El Lissitzky wrote his wife, Sophie, about Moholy; he was in Switzerland and she was still in Russia. I think this is one of the strangest pieces of writing I've ever seen by one artist about another. Lissitzky wrote: "I thought that Moholy would be more careful after the remarks by Kemény . . . and would only deal privately with stuff he has filched. . . . Here are the facts for you." So Lissitzky is writing to his wife at length, telling some apparently deep, dark secrets that he thinks she should know. It's phrased almost like a legal document. I thought it would be useful for me to read this statement in the context of this work, to address the question of originality and appropriation.

TB: I wonder if Moholy didn't much like Renger-Patzsch. If he calls this *The Water Head,* it may have been meant as an attack on Renger-Patzsch. I think Moholy is a more interesting figure than Renger-Patzsch, though. We don't think of Renger-Patzsch as a great teacher, as we do Moholy.

WN: Well, the Getty Center for the History of Art and the Humanities has many of Renger-Patzsch's letters and documents, and anyone who looks at those finds that he was, in his own way, an extraordinary teacher. In the archive are lecture notes and other material that suggest that while he wasn't as public as Moholy in his teaching, he did want to share his knowledge.

TB: But Renger-Patzsch was not a utopian thinker the way Moholy was. I use this not in a pejorative way, but I do think at times Moholy was messianic.

CH: In the catalogue for *The New Vision,* the 1989 show at the Metropolitan Museum of Art, Christopher Phillips writes about the relationships between Moholy and other photographers at the time, among them Ernő Kállai, who, Phillips says, "sought to debunk Moholy's oft-repeated pronouncement of photography's triumph over painting." Then Phillips goes on: "Kállai found an ally in the photographer Albert Renger-

Patzsch, who had by the late 1920s become Moholy-Nagy's chief public opponent. . . . Renger-Patzsch spoke for many professional photographers when he dismissed Moholy as an amateur pictorialist in modern dress, and ridiculed his call for radical experimentation with photographic optics and chemistry." That puts a different light on this piece.

KW: The diver's helmet has a very small window, so the diver has only limited vision; maybe that's also a comment on Renger-Patzsch. The smokestack, too, suggests tunnel vision.

TB: Here the diver is an object of ridicule and humor, a real "water head." This seems to be a loaded, savage satire, aimed directly at Renger-Patzsch. Renger-Patzsch did make some interesting pictures, and Moholy recognized that enough to publish *Factory Smokestack*, but that doesn't mean he liked Renger-Patzsch; he just liked the photograph.

LR: Irene-Charlotte Lusk, in her book *Montagen ins Blaue,* points out that Oskar Schlemmer created a diver figure as one of the characters in the *Triadic Ballet* as early as 1924; this may have been another source for Moholy. Lusk goes on to say that this pair of images, the *Wasserkopf* and the chimney, were conceived for a film script entitled "Dynamic of the Metropolis" in *Painting, Photography, Film,* where the chimney and the diver are juxtaposed with the caption, "Slanting chimney smokes; a DIVER emerges from it; sinks head-first into the water." On the same page is the image of an exploding volcano.

JF: This page is intended to demonstrate the extremes that the camera can reach: it can go to the top of the chimney or the bottom of the sea. Moholy often juxtaposed extremes in this way.

HM: But I think if that's all it was, he wouldn't have called it *Der Wasserkopf.* There's an insult in that.

WN: So Moholy used the Renger-Patzsch photograph three times—as a full-page plate, as part of his film sketch in *Painting, Photography, Film,* and then again in the *fotoplastik.*

CH: That brings up again the point you raised earlier, that he appropriated images

and used them in different contexts.

WN: And used them almost like notes in a musical score. This is also related to the idea of the relationship between production and reproduction. Think for a minute how people compose music today. They compose on electronic keyboards that record sequences of notes, and by pushing a button, they can have the sequence come back exactly. Before, composers had to write out every note every time. Here Moholy is using a quotation that's like the tape recording of a musical segment and retrieving it in different contexts.

TB: Another thing Moholy uses repeatedly is this network of background lines, which serves to connect different elements in the *fotoplastiks*. I'm interested that the diver comes from Schlemmer's *Triadic Ballet*, because this does look like a storyboard for a film. It's quite complex.

WN: Maybe Moholy was entranced by the Renger-Patzsch photograph for the same reason I love it: the beautiful line that runs up the side of the chimney. It's like a piece of drawing! That element is fundamental to the composition. And the network of lines in the background is, I think, similar.

TB: That line is actually the ground wire for the lightning rod. But it is important to the photograph. It would have been easy to walk around and not have that in it.

JF: But isn't he just playing with the idea of central perspective? He uses graphic elements in all his *fotoplastiks*. This leads back to Constructivist ideas, too.

CH: That seems like a good cue to talk about some of Moholy's own work in graphic design.

KW: We can start with *Verantworte!* (Be responsible!; pl. 41). It's from around 1930; it may have been designed as a book jacket.

TB: Despite his utopian side, I tend to view Moholy as apolitical. Do we know anything more about that?

KW: He wasn't overtly political in Germany, although social issues were very important to him. Nathan Lerner, who worked with him in Chicago, told me that Moholy generally suppressed his political views, because of his experiences in Hungary and

Germany. Nathan said he didn't even realize Moholy was Jewish until many years after Moholy's death.

JF: Maybe this piece has to do with elections in the Weimar Republic, a call for citizen participation. Or it could have been a poster design for a social organization, something like that.

KW: I don't think we can establish the exact meaning. It's a call to action, although we may not know what that action is.

JF: And yet he uses part of the face of a young, pretty woman, which you might expect to find in a cosmetics ad.

KW: Yes. That plays off strangely against the crowd scene. The mouth may be there to suggest the idea of speaking out, but it also suggests makeup.

WN: I am not persuaded that this is a book cover. It has the right shape, but it isn't divided at the right place for the spine.

TB: But it's a copy photograph—on the right you see the thumbtacks holding the original, and you don't see them on the left. So maybe it's just cropped.

JF: *Verantworte!* has an exclamation mark, which would suggest that it was meant to be a poster. The type, the cursive script, is very different from the sans serif type he usually used.

WN: It doesn't seem original enough to be by Moholy. It's not unsatisfactory, but it suggests the work of Rodchenko, Klutsis, or any number of German designers.

TB: It's really more like Piet Zwart's work.

KW: Moholy's wet stamp appears on the back of the print.

HM: Stylistically I think it fits in with his later advertising work. I definitely think it was commercial work. He didn't always stick with sans serif type of the sort Herbert Bayer used. I have business cards of his from the 1940s with his name written in the most beautiful copperplate script!

TB: It might be a poster or a dust jacket or a pamphlet. Maybe it's for birth control. So much of Moholy's work, particularly the *fotoplastiks,* is about domestic relationships.

And here he uses the mouth of an attractive woman. Women were responsible for birth control in the 1920s and 1930s—and to a large extent still are.

CH: Just to further that reading, most of the people in the crowd are men.

HM: But it's so blatant. It has a slogan. More than a few of his other montages, the *fotoplastiks*, have a jokey quality, but none of them have any text.

WN: Is the background a single image or several different scenes?

KW: It seems clear that they are different.

TB: It is like a little mystery. I think we can't know much more about the piece, because I don't think it's finished. Having done graphic design work myself, I have to say that this is set up beautifully to receive more type, in the empty space on the left-hand side. It doesn't seem enough to just say, "Be responsible." Responsible for what? For a particular election or for the size of your family?

WN: The design of *Verantworte!* is simple, almost abstract, compared with Moholy's cover design for a housing exhibition brochure (pl. 40).

KW: This is from about 1930; it's a cover design for the prospectus for a housing development. The happy worker is loaded down with children, one of whom is crying; behind them is a beautiful garden and a long, tree-lined drive going up to the manse. This is not the kind of home this guy is going to be able to own—therein lies the irony. So what's Moholy trying to say?

TB: I have to say that I don't think it's a particularly well-made montage.

WN: I have always found this to be a perplexing piece. First of all, it's very large. We have the original montage for this; it's about forty-three by forty-nine centimeters. What we're looking at is the copy photo Moholy made of it. The montage, in person, looks fabulous. It's a little like the photogram that we looked at earlier, *Photogram No. 1-The Mirror* (pl. 37). When you see that as a slide, you don't really appreciate its power as an object. This is the same.

Moholy was fascinated by all the different ways images could be reproduced. And he saved these shards—these prints are things that most artists would toss out! Instead, Moholy did the reverse—he tossed out the original. In our collec-

tion of a hundred works by Moholy, this is practically the only photomontage that we have; most other collections are the same. He threw out the originals and kept these printed replicas, which are like primitive photocopies. I think of this as the ultimate demonstration of the opposition that he and Lucia Moholy worked out, of the differences between production and reproduction. That seems to be the persistent theme in his art, year in and year out.

LR: I think Moholy has gone overboard here. He's flooded us with these highly manicured, aristocratic gardens, with trees planted in neat rows. He doesn't seem to have figured out how to handle all these elements. If he had dealt with the images of the man with the kids and the babies in the crib and then combined them with the landscapes, using other connective elements, it might have worked.

JF: The houses in the background, to the right of the man's ear, are actually housing projects built in the late 1920s to provide houses and apartments for workers. The Socialist government undertook many projects to help workers and the poor. There was a movement to provide decent, affordable housing for workers, called Wohnen zum Existenz Minimum (subsistence living). Architects at the Frankfurt School designed apartments of only one or two rooms plus a bathroom and a kitchen, trying to find ways to fit working families into small spaces with all the amenities they needed. People at the Bauhaus, too, tried to achieve this aim.

KW: Do you think Moholy is contrasting that with this other way of living?

JF: I don't think so. I think using pictures of these beautiful gardens was just an ironic way of saying that you can get a little paradise if you live in these new, modern housing projects.

TB: In America there have been two major books that have come out recently about the Weissenhof, as this architectural complex in Stuttgart was called. It's apparently still in excellent condition. One of the books describes how this came to be, and this montage doesn't seem to relate to it at all. I think you used the key word: there's an ironic quality to it. This movement went on throughout Europe, which to me seems remarkably progressive. But I don't get any feeling of that sort from this montage. It looks like a cartoon.

WN: The title points us to the buildings, but our eyes take us to the foreground and to all the gardens. So there's a contradiction between the nominal subject and the way the picture is constructed.

CH: I think Moholy is really making very sophisticated use of different visual metaphors for home. He establishes a flat texture of flowers and greenery, which is one symbol for home, and then plunges into the driveways to the mansions. That kind of separation between public space and private space is another symbol of home.

WN: I've gotten to like this, too, as I've given myself over to its sense of contradiction and chaos.

TB: In a way, I hate spending so much time on it. I think Moholy was a terrific designer, but I don't think these two pieces are major works. I know I don't do my most serious work when I illustrate books. It's interesting to talk about these, but I don't think this is where his real importance lies.

CH: He himself made such a point of the social utility of photography, though. He was obviously in favor of bringing sophisticated design to a mass audience.

Part of his message was to challenge the notion of the authorship or the authority of the genius artist. It's important to try to understand his work in terms of his own ideas about what he was doing and not apply our concept of the masterpiece or the original to it.

KW: His photographs certainly aren't beautiful, in a conventional sense. There isn't a body of pristine prints that people can appreciate.

JF: But maybe that's not really the point. It was certainly not his aim to produce the perfect print.

TB: In a general sense, in Europe between the wars the fine print was not an issue. Bill Brandt was an indifferent printer. Cartier-Bresson didn't care about the fine print. There are exceptions—Walter Peterhans, for example, made magnificent prints. But in general, the European philosophy was for harder grades of contrast. Americans made a fetish of the print.

I think it's okay that Moholy's prints are not "beautiful." But so many of the prints have faded and now have beautiful tones that were never there originally. It's

hard to say what any of us might have thought about them if we'd seen them in 1935, let's say, or 1929. Many of them have changed.

LR: Many of the materials Moholy worked with were very fragile, and many of the works did not survive. Other things, for one reason or another, got lost. Recently I've seen Plexiglas works that date from roughly 1937 to 1946. I would say at least three-quarters of them are markedly deteriorated. The Plexiglas has fractured or been scuffed, marred, or chipped. His acceptance of the role of chance in determining the work somehow seems to be in keeping with the fact that the work is always changing. He used photographic materials that were going to fade over time. Photographers of the time didn't know about, let alone care about, adequately fixing a print.

KW: His is a very different aesthetic from, say, Stieglitz's. I think it's an aesthetic that's difficult for people to appreciate, and maybe more cerebral.

CH: Another reason people may find it hard to appreciate him is that we look at the work from a very different viewpoint. In the 1930s, many artists embraced technology as a way to transform the world, transform consciousness, solve the problems that had been acted out in terribly bloody terms during the First World War. But we look back from our post–Second World War and post–atomic age perspective and say that technology is not in itself the answer to all of our problems. This is a crucial shift.

JF: Another important point is that Moholy was not a cynic. Maybe this is one reason why people today don't look at him and his work as they should. He is not like McLuhan, who is completely cynical in his description of how society works. Moholy never was. On the contrary, he always argued that the modern artist should involve the viewer, that good art should not exclude the audience, that good art should try to give modern man an easier handle on our modern environment. Art should be something like a mediator between people and the technological society we live in.

CH: As for many other artists in that period, the photograph was for Moholy an intermediate step toward a reproduction in a magazine or a book. It was not in itself an object to be hung on a wall. It was a different time. The real sense of photography's potential was as a mass medium, a way to break down the sense of art as framed paintings that would hang on the walls of the wealthy.

LR: It was a visual conduit to a series of ideas.

KW: In 1929 Moholy wrote, "I do not believe so much in art as in mankind." Obviously he considered art very important. But he wasn't that interested in making objects to sell that would last a thousand years.

TB: In recent years I think many of Moholy's ideas have been distorted, and some scholars have conflated his predictions with fascism. Some people misread his idealism as a kind of taking over and censoring of all other art views except those he deemed necessary for man. It's unfortunate, because I think that he did believe in mankind. He believed that these inventions could lead to a better life. At one point he wrote that the way man would progress would be to have a parliament of design, and that would change how we lived.

CH: For Moholy, photography was a way of extending perception, instructing our senses to see the world in a different way. In *Vision in Motion* he talks about the need to bring our senses and emotions up to speed, to keep up with the vast increase in technical skills brought about by the industrial revolution.

TB: I don't see how Moholy did everything, writing, teaching, making work!

HM: He never slept. Not much. And he had help, from his wives and others.

KW: Well, if you know that your material needs will be taken care of, that frees you to do other things.

HM: But they helped in his work, not just in meeting his material needs. My mother typed all his manuscripts. He never learned to drive; she drove him everywhere.

TB: Here he promoted the wonders of the modern age, and yet he never learned to drive. Talk about contradictions!

LR: I came across this wonderful article that was in the *Saturday Evening Post*, July 3, 1943. The title is "Are You Contemporary?" And it says, in an inimitable *Saturday Evening Post* lead, "Check your mind against Moholy-Nagy's, a modernist who is so far ahead that he is almost out of sight." It talks about different objects and projects that were done at the School of Design in Chicago, where they took, for instance, a

garbage can, and "with infra-red rays the Chicago modernists roasted a chicken in 23 minutes, ate it in less."

CH: One of the things that I find interesting about some of these *fotoplastiks* is that he is very aware of being contemporary.

KW: A work that seems very contemporary to me is *Olly and Dolly Sisters* (pl. 23), from around 1925. The title refers to a 1920s music hall team, the Dolly Sisters. The most interesting thing about the picture is its startling simplicity.

LR: It's so minimal. A woman is sitting on a globe, and her face has been replaced by a black dot, which is a smaller version of the globe. Off to the right is an equivalent black dot, left there to levitate, if you will, in this blank space. The shapes are carefully balanced. The figure is enticing, and yet there is nothing erotic about it.

TB: I think this is a very humorous piece. I read this as a large circular mouth with two eyes! This was a dance team; it's as if they were happy faces. Moholy has constructed a powerful graphic device. It's a bit crude in its construction. Moholy was so full of visual ideas that I always wonder, when I see a piece like this, if it was a finished piece.

WN: Well, there's an answer to that. This print is the biggest *fotoplastik* in our collection. It looks fabulous! You get little sense of it in the slide, but the original commands space in a very authoritative way.

HM: I've seen the original piece, which is in the Sigfried and Carola Giedion Collection in Zurich.

WN: So they have the original montage?

HM: Yes. It's a little postcard.

LR: There's an obvious comparison to be made with John Baldessari's work. He uses the same device of placing a dot over a person's face so that you have to work to form an interpretation. Just as Moholy does here, Baldessari often blocks out what we want to identify as the personality of the person, the face. Where this piece is black and white, Baldessari uses color, often working with the three primary colors: red, yellow, and blue.

TB: I think it's important to bring Baldessari in, but I think that's hindsight.

CH: We discussed how Moholy's montages, where the elements are linked by lines, are so spare and different from what other people were doing at the time. Here he does something even more spare. He's jettisoned the whole supporting structure of Constructivist lines, and he's working with these three dots and one cutout figure. At the same time, it's extremely complex. You have the absent twin, the double who is not there, only indicated by the dot. Even the title is a play on language, about the idea of reproduction.

TB: Perhaps the two black eyeholes and the mouth are the face of the absent sister. Even with such a tantalizing title, it may still be nonsense. He may have just liked the sound of the two words together.

LR: Another contemporary artist who comes to mind in relation to this work is Bruce Nauman. He has dealt with nonsense, sound, and the image of the clown in his work, all of which you can find here.

WN: As a transition to a conclusion, I would like to recall the statement Moholy made about the permanent necessity for new experiments. He seems almost to have given himself the mandate not to let a day go by without undertaking a visual experiment. We're lucky that he chose photography to carry out some of his most important experiments. The sense of contradiction is what keeps me interested in the art, the fact that he always gives us the unexpected. Good artists always surprise us, and that's why they're good—they continually deliver surprises that are not easy to decipher.

CH: It's hard in a conversation like this, where we're focusing on a small group of photographs, to do justice to the multifaceted quality of his achievement—as a theorist, as a teacher, as a writer, as a painter, sculptor, filmmaker, all of the fields he was active in.

One of the things that I find most striking about his writing is his emphasis on photography as a tool for improving us as humans. In 1932 he wrote that new forms of photography open up "a new field of visual presentation in which still further progress becomes possible." He talked about being able to fix movement in a thousandth of a second, and he said: "This advance in technique almost amounts to a

psychological transformation of our eyesight. Photography imparts a heightened or, insofar as our eyes are concerned, increased power of sight, in terms of time and space." He was really making an argument for the importance of photography as a way to allow us to see the world better.

KW: I think he very much believed in it.

CH: I think so, too. But the brilliance of his thinking has often tended to overshadow his pictures. Something like *Olly and Dolly Sisters* is complex and layered and at the same time simple and powerful. You can see it simply as a blending of Dada collage and Constructivist formal simplicity. It also prefigures the whole interest among artists today in media, in reproduction, in celebrities.

WN: I think there's another element that Baldessari and Moholy share, and that is the desire to make the familiar seem strange. Baldessari pulls familiar subjects from the popular media, just as Moholy has done here with *Olly and Dolly Sisters.*

When I phrase it in that way, "making the familiar seem strange," we get back to Surrealism again. That's a phrase that would somehow seem much more appropriate as a description of a Surrealist artist. But he brings it back to Constructivism.

TB: Yes. The roots come out of Russian Constructivism.

CH: One of the issues we should touch on is what influence Moholy-Nagy has had on artists and photographers today. Lee and Tom, as artists yourselves, what do you think?

TB: Certainly as an art historian, I have been tremendously influenced by him. When I was a student at the Institute of Design, there were still creative problems assigned that he had developed, and there were people around who had known him— he was still there in many ways.

But it was the work that got me first—just seeing the prints. Not the myth, and not the writing. I've come to the writing much later in my life, and I am astounded by how prophetic he was. Moholy was a true genius. Today we don't see artists who deal with the kinds of social problems that he did, with such a wealth of imagination. He was really a remarkable figure.

LR: I never met Moholy, but when I organized a show of his work many years ago I

was able to live with his prints. I was most fascinated when I was able to show the work to someone who was invited here today but who regrettably couldn't come, Nathan Lerner. I asked Nathan what it was like to be around Moholy on a daily basis. He said the man had an almost childlike enthusiasm and an adventuresome spirit, which we have mentioned over and over today. He said he also had a certain innocence. With that mix he was able to create all the different forms we've talked about today: photograms, photocollages—*fotoplastiks,* if you will—and, finally, camera images. And Moholy was only fifty-one when he died. Many artists are just starting to hit their stride at that point.

Some years ago Beaumont Newhall told me a great anecdote. He said that he once visited Moholy in Chicago, and they were looking at a stack of prints together. When they were finished, Moholy tossed the pictures onto the ground, much to Beaumont's chagrin. At one point, Beaumont said, Moholy looked down at a print on the floor and said: "Look at those forces! Look at the arrangement of those objects!" It was as if he were seeing the photograph for the first time. That sense of openness, of discovery, seems to have been the essence of the man.

Lucia Moholy. *Bauhaus, Dessau,* 1925–26.
Gelatin silver print, 5.7 × 8.1 cm.
85.XP.384.100.

Chronology

1895

Born July 20 to Lipót Weiss and Karolin Stern in Bácsborsod, Hungary.

1896–1913

After his father leaves, László moves with two brothers to the town of Mohol in southern Hungary. He adds the name of the town as a prefix to his uncle's last name. Moholy-Nagy later moves to the city of Szeged to attend secondary school.

1914

Law studies at the University of Budapest are interrupted by World War I; Moholy-Nagy serves as an artillery officer in the Austro-Hungarian army.

1915–17

Develops an interest in poetry and drawing during the war, and after being wounded, devotes himself to these pursuits during a period of convalescence in Odessa, Russia. Begins publishing poems in the Hungarian literary journal *Jelenkor* (The present age).

1918

Briefly continues law studies in Budapest after being discharged from the army. Begins evening classes in life drawing and soon devotes his energies to art, painting and drawing in a representational and somewhat Expressionistic style. Hungarian Revolution results in the country's withdrawal from the Austro-Hungarian Empire at the end of October. The Council of Soviets, a coalition government of Socialists and Communists, is formed the following spring under the leadership of Béla Kun. Moholy-Nagy's application for membership in the Communist party is rejected due to family land ownership and his service as an officer during the war.

1919

Under Kun, the National Museum of Fine Arts in Budapest acquires drawings by Moholy-Nagy. After the fall of the Kun regime, he moves back to Szeged, where his work is shown in December. Leaves for Vienna the same month and associates with artists and political activists, led by Lajos Kassák, centered around the periodical *MA* (Today).

1920

After six weeks in Vienna, moves to Berlin in late January. Meets Lucia Schulz in April. Becomes acquainted with Berlin artists, including Dadaists. Exhibition at the Fritz Gurlitt Gallery in October. In painting, begins exploring color and nonobjective form, rejecting naturalistic representation for a style related to Russian Constructivism and the Suprematism of Kasimir Malevich. *Realist Manifesto,* announcing the death of easel painting, published by Naum Gabo and Antoine Pevsner.

1921

Marries Lucia Schulz on January 18. First appearance of his work in *MA* in the March 15 issue; he is the subject of the September 15 issue. Works as a Berlin correspondent for the journal until July 1922; broadens its scope to cover international art in a variety of media, with emphasis on photographic illustrations of new work. His studio becomes a popular meeting place for artists. Shares authorship of "Aufruf zur elementaren Kunst" (Manifesto of elemental art) with Dadaists Raoul Hausmann and Hans Arp as well as the Russian artist Ivan Puni, published in October in the periodical *De Stijl* (The style). Begins writing "typophoto" (film scenario) entitled "A nagyváros dinamikája" (Dynamic of the metropolis).

László Moholy-Nagy. *Lucia Moholy*, 1924–25. Gelatin silver print, 7.9 × 4.6 cm. 90.XM.97.

1922

First exhibition in Berlin at the Galerie Der Sturm in February, showing abstract paintings and metal sculptures alongside paintings and reliefs by Hungarian László Péri. Positive review of exhibition by Russian artist El Lissitzky. Begins making cameraless photographs (photograms) in collaboration with Lucia Moholy. In July, publishes first article on photography and film, "Produktion-Reproduktion" in *De Stijl*. Collaboration with Kassák on *Buch neuer Künstler* (Book of new artists), an anthology of modern art and design with an essay on the relationship of the artist to society by Kassák and a large section of illustrations— ranging from Russian paintings to dynamos and race cars—selected and arranged by Moholy-Nagy. With Alfréd Kemény writes the manifesto "Dynamisch-konstruktives Kraftsystem" (Dynamic-constructive system of forces). Attends the Dada-Constructivist Congress in Weimar and the Congress of Progressive Artists in Düsseldorf. *Erste Russische Kunstausstellung* (First Russian art exhibition) held at the Galerie Van Diemen in Berlin in October. Produces "telephone pictures," five panels that he designed and had made from industrial materials at an enamel factory, with the idea that such pictures could be ordered over the telephone.

1923

Invited by Walter Gropius in April to join the staff of the Bauhaus in Weimar, succeeding Johannes Itten in teaching the *Vorkurs* (preliminary course) during the second semester and the metal workshop. His Constructivist approach is greeted with mixed acceptance by students and teachers aligned with German Expressionism. The *Kestnermappe*, a group of six lithographs by Moholy-Nagy,

is published in an edition of fifty by the Kestner Gesellschaft in Hanover. Publishes "Light: A Medium of Plastic Expression" in the American periodical *Broom*, which features four illustrations by Moholy-Nagy and four by Man Ray.

1924

One-man exhibition at Galerie Der Sturm in Berlin. Begins working with photomontage.

1925

With Gropius, edits and designs a total of fourteen volumes of the *Bauhausbücher* series (projected fifty titles) from 1925 to 1929, offering an overview of art, architecture, and design in Europe in the 1920s. Written in the summer of 1924, *Malerei, Photographie, Film* (Painting, photography, film) is published as the eighth volume of the *Bauhausbücher* series (the spelling is changed to "Fotografie" in the 1927 second edition). Another volume in the series, *Die Bühne im Bauhaus* (The theater of the Bauhaus), by Moholy-Nagy, Oskar Schlemmer, and Farkas Molnár, is published. Withdrawal of state financial support due to changing political climate causes the Bauhaus in Weimar to close on April 1. Moholy-Nagy and Lucia move to Dessau.

1926

The new Bauhaus building in Dessau, designed by Walter Gropius, is completed and inaugurated on December 4. Darkroom facility available in the Masters' House. Coeditor with Walter Gropius of the Bauhaus quarterly journal. Completes first film, *Berliner Stilleben* (Berlin still life).

1927

Becomes film and photography editor for *i 10 Internationale Revue,* an art magazine published monthly in Amsterdam.

1928

"Fotografie ist Lichtgestaltung" (Photography is creation with light) is published in the Bauhaus journal. Moholy-Nagy, Herbert Bayer, and Marcel Breuer leave their teaching posts at the Bauhaus after director Walter Gropius resigns in March. Subsequently works as a commercial artist in Berlin, specializing in graphic design, stage sets, photography, and film work.

1929

Moholy-Nagy's *Von Material zu Architektur* (From material to architecture) published (English-language edition published in 1932 as *The New Vision: From Material to Architecture*), outlining his teaching philosophy for the Bauhaus preliminary course. The title is his second (and the fourteenth and last) in the *Bauhausbücher* series. Involved in selection of work for the Deutschen Werkbund international exhibition *Film und Foto* in Stuttgart (May 18– July 7). Ninety-seven photographs by Moholy-Nagy are shown together in a separate gallery. A selection of works from this exhibition, including two images by Moholy-Nagy, appears in *Foto-auge: 76 Fotos der Zeit* (Photo eye: 76 photos of the period), edited by Franz Roh and Jan Tschichold. *Es kommt der neue Fotograf!* (Here comes the new photographer!) by Werner Gräff is also released, celebrating many of the camera techniques employed by Moholy-Nagy but with no illustrations of his work. Makes film *Marseille vieux port* (Old port of Marseille). Separates from Lucia Moholy. Creates stage designs for the Kroll Opera in Berlin and Erwin Piscator's Political Theater. Photography workshop established at the Bauhaus under the direction of Walter Peterhans.

1930

Light-Space Modulator completed and shown in the International Werkbund Exhibition in Paris, along with the film made with it, *Lichtspiel schwarz-weiss-grau* (Light display black-white-gray). Roh's book *L. Moholy-Nagy: 60 Fotos* presents selections from Moholy-Nagy's exhibition at the 1929 *Film und Foto* exhibition. Photographic work exhibited at *Das Lichtbild* exhibition in Munich. Expands studio and hires György Kepes, a young Hungarian artist, as his assistant. Produces book jackets, advertising work for periodicals. Trip to Scandinavia with the actress Ellen Frank.

1931

Meets Sibyl Pietzsch, a scriptwriter working for a film syndicate in Berlin. Photographs exhibited for the first time in the United States at Delphic Studios in New York (October 12–25). Beaumont Newhall purchases works from exhibition for the photography collection at the Museum of Modern Art. Bauhaus in Dessau closes due to withdrawal of municipal funds under National Socialist party rule.

1932

Continues work in film medium with *Zigeuner* (Gypsies) and *Tönendes ABC* (Sound ABC; presumed lost). Bauhaus reopens briefly in October in Berlin before being shut down completely in April 1933.

1933

Hindenburg appoints Adolf Hitler chancellor of Germany in January. Burning of the Reichstag building in February. Moholy-Nagy travels to Athens to attend the Congrès Internationaux d'Architecture Moderne, July 29–August 13, and film the proceedings. Makes first visit to London at the invitation of Herbert Read and is hired as the art director for the new Dutch periodical *International Textiles*.

1934

Commercial work in Amsterdam. Experiments with color photography. Designs exhibit for Dutch Rayon Manufacturers in Utrecht. Divorced from Lucia Moholy in Budapest.

1935

Moves to London in May; explores idea of re-creating the Bauhaus there with Walter Gropius. Marries Sibyl Pietzsch, with whom he has two daughters, Hattula (b. 1933) and Claudia (b. 1936). Acts as design adviser to commercial firms such as Imperial Airways, London Transport, and Simpson's (a department store). Makes documentary film *Life of the Lobster,* filmed in Sussex and at an aquarium in Scotland. One-man exhibition in Brno, Czechoslovakia, organized by František Kalivoda, editor of *Telehor.*

1936

In *Telehor,* defends his decision to continue to paint and exhibit work. The periodical devotes its sole issue to Moholy-Nagy. His photographs are published in Mary Benedetta's *The Street Markets of London.* Begins film *The New Architecture at the London Zoo.* Creates special effects for the film *The Shape of Things to Come,* not used in final version. Exhibition at the Royal Photographic Society opens in April.

1937

Moves to Chicago in July, accepting an invitation to become director of the New Bauhaus, a design school that opens October 18 with about thirty-five students. Kepes moves to Chicago to become part of the teaching team. Photographs taken in London

with Leica camera published to illustrate *Eton Portrait* by Bernard Fergusson. *Entartete Kunst* (Degenerate art) exhibition opens in Munich in July, including work by Moholy-Nagy and many of his friends and associates, and travels to thirteen German and Austrian cities through 1941.

1938

After its first year, the New Bauhaus closes for financial reasons. Alfred H. Barr organizes the exhibition *Bauhaus, 1919–1928* at the Museum of Modern Art, including work by New Bauhaus students.

1939

Moholy-Nagy and some members of the former New Bauhaus faculty open the School of Design in Chicago (renamed the Institute of Design in 1944 and incorporated into the Illinois Institute of Technology in 1949). First year of summer classes held at Rumney Place, near Somonauk, Illinois. Photographs taken with Leica in London published in *An Oxford University Chest* by John Betjeman. Designer for commercial firms, including Parker Pen Company; Spiegel, Inc.; and the Baltimore & Ohio Railroad.

1940

School of Design summer session at Mills College in Oakland, California.

1941

The United States enters World War II. Supplies become scarce due to the war; many students and faculty join the military. Moholy-Nagy becomes a member of American Abstract Artists.

1942

Five students receive Bachelor of Design degrees from the School of Design on June 5.

1943–44

Begins writing *Vision in Motion* (published posthumously in 1947).

1945

President of the Chicago chapter of the Hungarian American Council for Democracy. Becomes ill with leukemia.

1946

Becomes a naturalized American citizen. Retrospective exhibition organized by the Modern Art Society (later the Contemporary Arts Center) at the Cincinnati Art Museum. Dies in Chicago on November 24.

Editor	Gregory A. Dobie
Designer	Jeffrey Cohen
Production Coordinator	Stacy Miyagawa
Photographer	Ellen Rosenbery
Typesetter	G & S Typesetters, Inc.
	Austin, Texas
Printer	The Stinehour Press
	Lunenburg, Vermont